Acrylics
WorkshopII

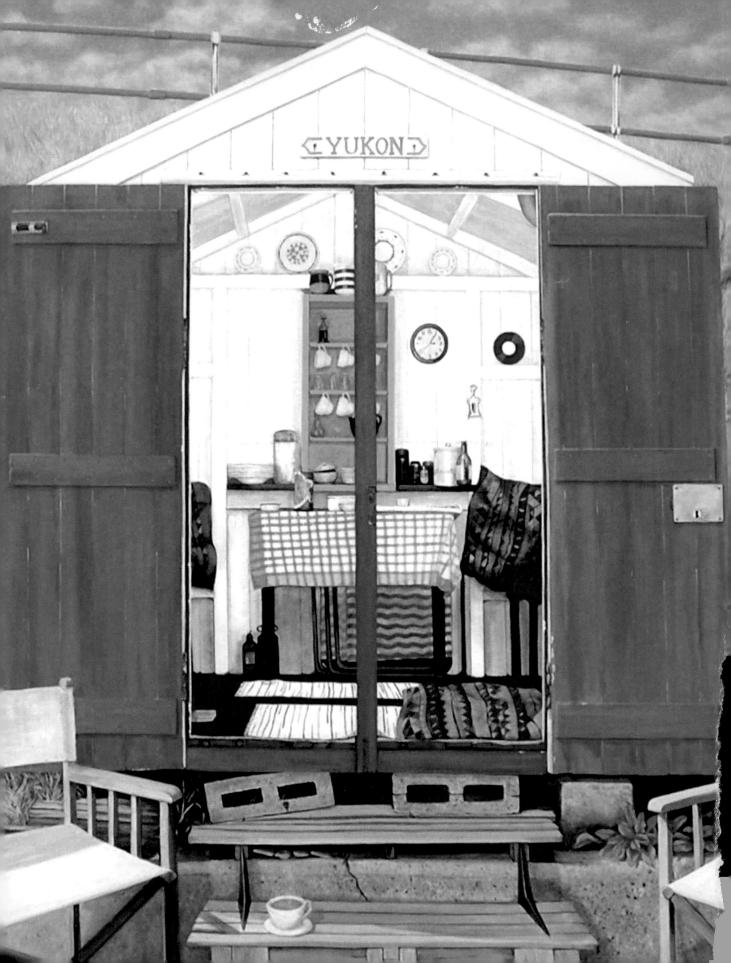

Acrylics
Workshop II

Karen S.J. Keable

A Dorling Kindersley Book

LONDON, NEW YORK, MELBOURNE, MUNICH, DELHI

Project Editor Kathryn Wilkinson
Managing Editor Julie Oughton
Managing Art Editor Christine Keilty
Production Editor Sonia Pati
Production Controller Rita Sinha

Produced for Dorling Kindersley by cobalt id
The Stables, Wood Farm, Deopham Road,
Attleborough, Norfolk NR17 1AJ
www.cobaltid.co.uk
Editors
Marek Walisiewicz, Sarah Tomley
Art Editors
Paul Reid, Rebecca Johns

First published in Great Britain in 2008 by
Dorling Kindersley Limited
80 Strand, London WC2R 0RL

A Penguin Company

2 4 6 8 10 9 7 5 3 1

A CIP catalogue record for this book
is available from the British Library.

ISBN: 978 1 4053 2900 2

Printed and bound in China by
Hung Hing Offset Printing Company Ltd

Discover more at
www.dk.com

Contents

 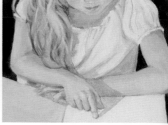

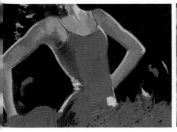

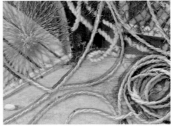
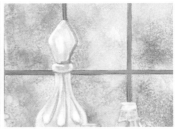

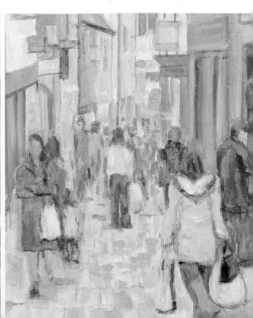

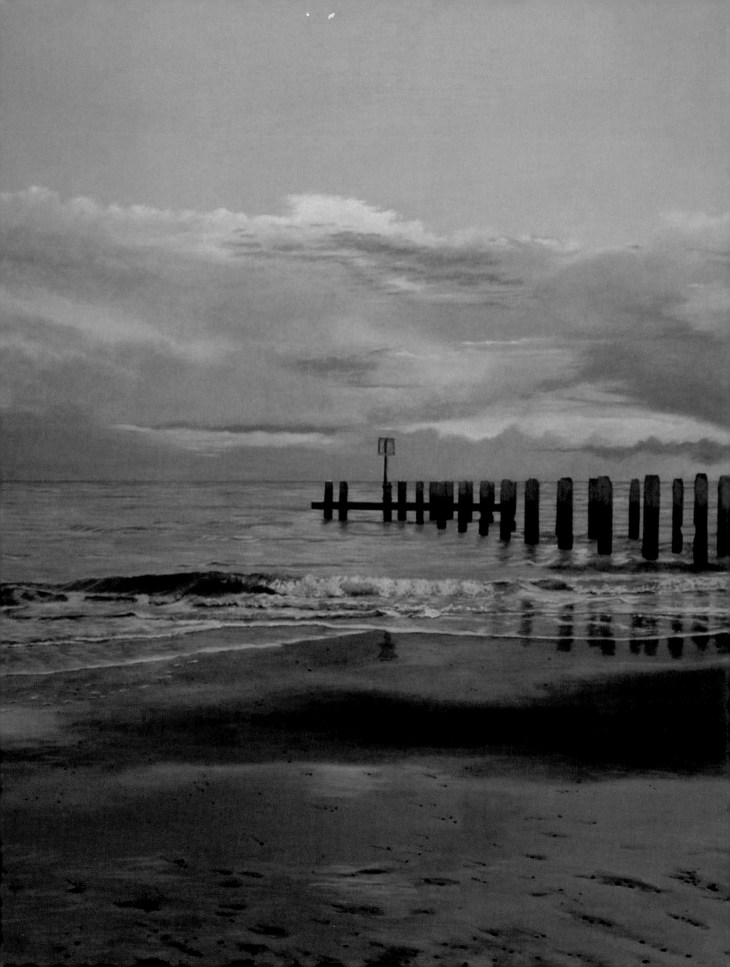

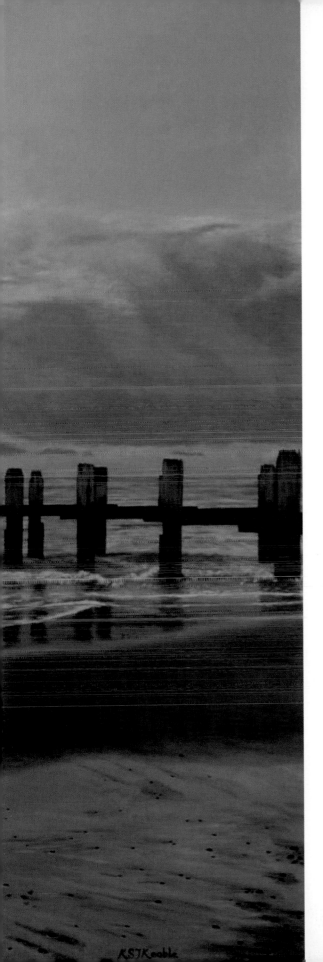

Introduction

Acrylic paint is a modern medium, invented in the mid-twentieth century, and it is perfectly suited to the demands of the contemporary artist. The paints use the same pigments as oils and are available in an equally brilliant range of colours. The difference lies in the fact that they are bound together in a quick-drying plastic resin, which has enormous benefits for the artist. You can paint on location and then get up and go; you can mix the paints with virtually every other kind of medium to create unusual and interesting effects; and you can easily correct any mistakes simply by painting over them. These are paints that fit in well with a busy lifestyle: an acrylic painting can be a long-term work in progress, to be continued when you have time. The paints are quickly and easily cleaned with water alone, and do not emit toxic fumes. These properties make acrylics the most versatile of paints — the perfect choice for artists today.

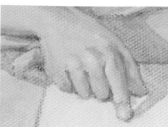
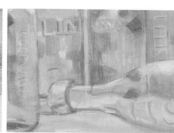

Improving your skills

In this book you will learn to build upon the skills that you have already acquired, to further the options open to you as you paint, make better decisions, and achieve more satisfying results. You may already have a good grounding in basic techniques, mixing colours, and creating pleasing compositions, but want to take this basic knowledge further. This book will guide you through new, exciting techniques using specialist paints and mediums to enhance the versatility of acrylic paint, allowing you to create anything from translucent washes to thick layers of textural impasto.

The theoretical sections at the start of each chapter will remind you of the basic rules and techniques, while also asking you to experiment with new ways of seeing and of expressing yourself on canvas. The step-by-step projects then provide a forum where you can develop these techniques; you will explore, for example, the manipulation of light and shade, the use of dynamic perspective, and how to lead the eye using colour, contrast, and detail. As you learn new ways of planning, sketching out, and completing your pictures, you will gain in confidence as an artist, and begin to express a truly individual style.

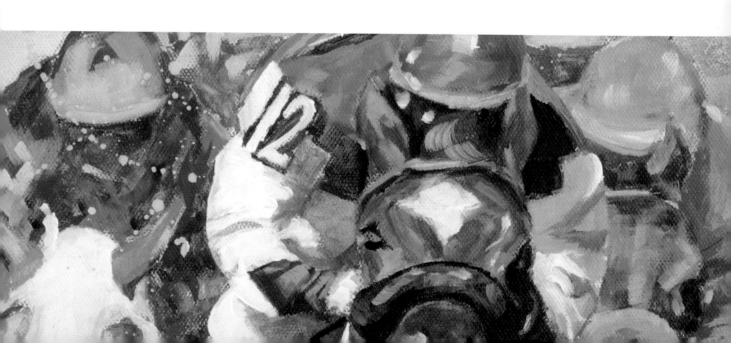

Successful painting

The aim of this book is to help you improve your understanding of acrylic paints, broaden your skills, and enhance the quality of your work. It also aims to give you new ways of imagining your paintings before you start, by demonstrating different ways of composing a painting, the possibilities of limited palettes, and the ways in which colour and contrast can be used to express emotion. The projects in this book are grouped into four sections: Still Life, Life and Portrait, Landscape, and Contemporary. Each type of painting requires a very specific approach and throws up different problems and considerations for the artist – many of which are addressed in the theoretical and practical step-by-step sections. Each section also includes both short exercises and extended projects to allow you to experiment with new tools and techniques. The extraordinarily varied types of painting that can be obtained with acrylics is demonstrated through a gallery area within each section, showing the works of different artists in the genre. The final section looks at ways in which you can really push the boundaries of your approach to find a uniquely personal style.

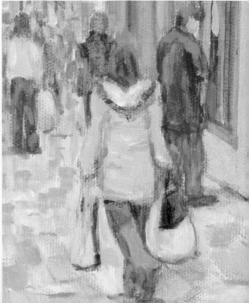

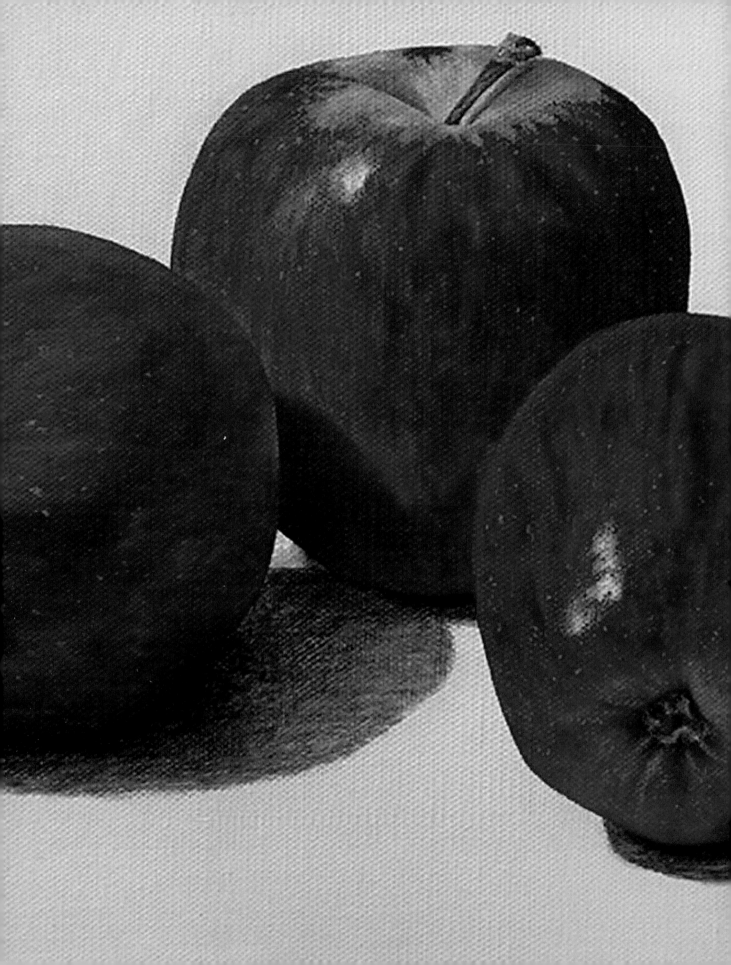

Starting Points

Materials

Acrylics can be sculpted like oil paints or combined in washes like watercolours; they are excellent in collages and have the adhesive qualities for use on walls. Not surprisingly for such a versatile medium, acrylics are produced in great variety, and many different additives have been developed to alter their characteristics. Time spent experimenting with finishes, techniques, and tools is a wise investment.

PAINT

There many brands of acrylic paint, with considerable variety in cost and quality. Look out for the labels "student" or "artist'" on the tubes. Artists' paints are more expensive, but are high in quality, with good permanence, brilliance, and intensity of colour. Students' paints tend to be a little duller, but can be useful when you wish to experiment with colour and techniques without the inhibitions of cost.

Students' paints These are smooth and free-flowing. They are cheaper than artist-quality paints because they contain synthetic pigments and a higher percentage of binder. Available in around 30 colours.

Artists' paints These have a soft, buttery consistency, which holds brush marks very well, and excellent brilliance. They can be used for textural techniques, such as impasto, without the need for a medium. Available in around 80 colours.

BRUSHES AND STROKES

Acrylics tend to be hard on brush fibres, and many artists prefer tougher synthetic brushes to natural hair. To begin painting, you will need both stiff-bristled brushes for applying thick paint and soft-bristled ones for watercolour effects and softer marks, such as those in portraits. Start with a mixture of brush sizes and types, such as those shown below.

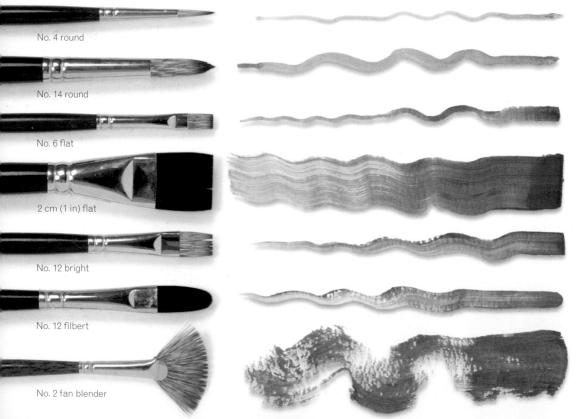

No. 4 round

No. 14 round

No. 6 flat

2 cm (1 in) flat

No. 12 bright

No. 12 filbert

No. 2 fan blender

Small round This brush is perfect for fine lines and detailed work.

Large round Makes bold, vigorous lines and can be loaded heavily with paint.

Small flat Use the tip of this brush for fine lines and small touches.

Large flat This brush is perfect for blocking in large areas of colour.

Bright Similar to a flat, but with shorter hairs, this brush makes strong textural marks.

Filbert This brush is good for producing soft, tapered strokes.

Fan blender Use this brush to blend paint on the support or soften brushstrokes.

CHOOSING THE RIGHT SUPPORT

Acrylics can be used on a wide range of supports, including paper, board, canvas, wood, and metal. The key thing to remember is that acrylics will not adhere to any surface containing oil or wax; if you buy a pre-primed support check that it has been prepared with acrylic primer, not an oil-based one.

All surfaces should be primed with an acrylic gesso primer. A white gesso can be used to add an underlying layer of luminosity, while a mid-toned, coloured gesso will provide a neutral background, making it easier to judge colour values. For experimental work, try using decorator's emulsion.

Canvas This can be made from natural fibres, such as cotton or linen, or synthetic ones. Natural fibre canvas has a coarse grain and springy texture that can add vitality to a painting; synthetic versions are exceptionally durable.

Canvas board Here the canvas has been glued on to a panel, providing a rigid surface with increased texture. This is a good surface to use if you want to work in heavy, textural paint or mixed media, or if you like to work on location

Primed board Almost any kind of board can be sealed and primed for painting. Simply use one or more coats of gesso, depending on how smooth you wish the painting surface to be. Sand between layers or allow a texture to develop.

MDF/Masonite This can be used as a painting surface if sealed and primed, or as a rigid surface under paper. Note that compressed boards may warp over time, and their silicones can seep into the paint, discolouring a picture.

Paper Certain types of paper have been designed specifically for use with acrylic paints, but even these are not really strong enough to support a picture featuring thick, heavy layers of paint. Several weights and textures are available.

MEDIUMS

Acrylic paint dries quickly, and once dry, is very stable. This allows you to paint quickly in many layers without disturbing those below. However, some techniques require a more fluid paint or a thicker texture, and so the paint needs to be modified using a medium. Mediums can increase the workability of acrylics and greatly extend the range of techniques and effects at your fingertips.

Acrylic retarder (gel medium) This is a translucent gel that extends the paint's drying time, while also thickening it slightly. It allows you to work wet on wet, and is useful for heavier impasto work.

Acrylic flow improver (enhancer) This medium increases the flow of the paint while maintaining the intensity of its colour. It is useful for applying flat areas or washes of colour without losing vibrancy.

Acrylic gloss or matt medium These gel mediums add body to the paint, lengthen drying time, increase the paint volume, and retain brush marks. They add a gloss, matt, or dead flat finish as required.

Varnish Once your painting is completely dry, you may want to protect it from discolouration or dirt using a coat of matt, gloss, or satin varnish. This does not affect the flexibility of the painting, unless you use one made specifically for rigid surfaces. Varnish can be removed with white spirit if necessary.

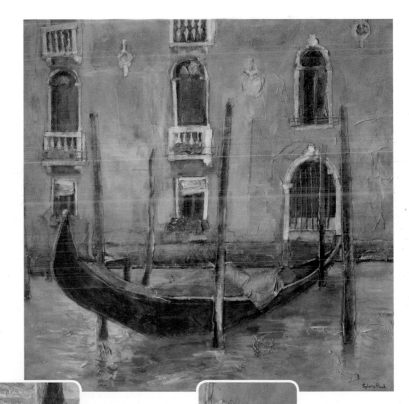

Gloss medium
The glow of light on the water has been created partly by adding gloss medium to the paint.

Matt medium
This medium has been added to the paint to create areas of raised texture, echoing the crumbling wall.

Working with paint

Acrylic paints have their own set of characteristics, which you can choose to exploit directly or modify in a number of ways to increase your creative repertoire. For example, acrylics dry fast, which is a boon when you need hard edges, but calls for quick work if you wish to blend colours. Similarly, acrylics naturally have a slight sheen, which may be desirable. If not, it can be modified by the addition of matt medium.

SPECIALIST PAINTS

Conventional acrylics can be altered through the use of mediums, but some effects are best achieved by using specialized types of paint. Fluid acrylics, for example, flow from the brush more easily and can produce watercolour-like effects without loss of vibrancy or colour. And light-reflective acrylics will add a luminous quality to your paintings.

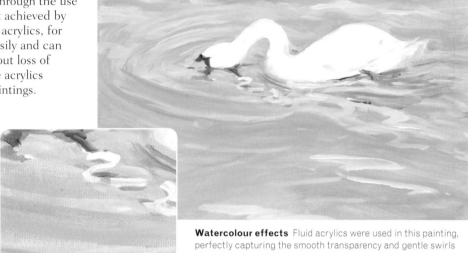

Fluid acrylics Also known as soft-bodied acrylics or "jar colours", these are semi-liquid, highly pigmented acrylic paints. They are especially useful for watercolour techniques, as they flow easily and blend together naturally on the surface. Some artists use the paints to pour or drip on to the support; they can also be combined with mediums for a range of effects.

Watercolour effects Fluid acrylics were used in this painting, perfectly capturing the smooth transparency and gentle swirls of the water. The paint was applied on to wet paper, to increase the natural blend of the paint, and built up in layers.

Buildings highlighted with fluorescent orange draw the eye deeper into the picture and create a focal point.

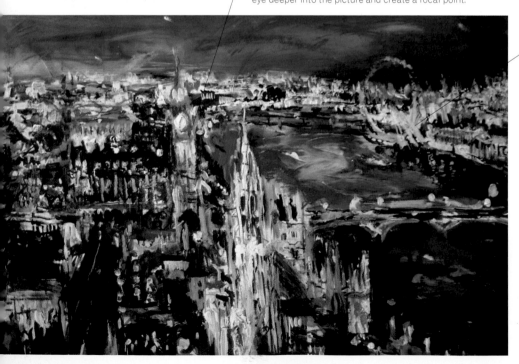

The form of the ferris wheel is painted in small, suggestive strokes, but its light colour and circular shape draws our attention.

Light-reflective paints These acrylics contain titanium-coated mica flakes, which have a glittery appearance under light. They are variously known as iridescent, pearlescent, or metallic paints, and can all be mixed with standard acrylics to give your paintings a luminous quality. These paints are used to best effect on a dark background, where they expand the range of tonal values. This is exemplified in the painting of London (*left*) where the dark sky and foreground are pierced by luminous colour, creating the vibrant atmosphere of the city at night.

CHOOSING WEIGHT AND TEXTURE

Acrylic paint can be used in a wide variety of weights, from thin translucent, delicate washes to heavy, textural impasto. Mixing the various techniques within one painting adds depth and interest and increases your range of expression.

A translucent wash may suggest the background, building towards a textured foreground for extra perspective and dimension. Use a medium where necessary to change the density of the paint without any loss of colour or adhesion.

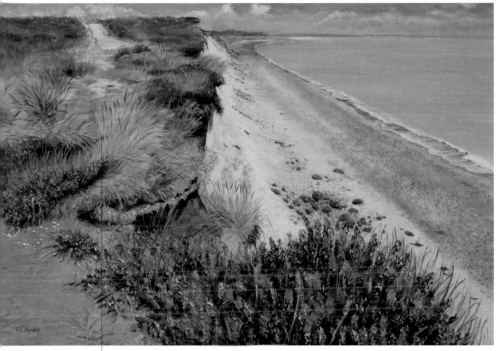

Using heavy paint Modelling pastes or textural gel mediums can be used to produce a variety of effects. They can be mixed with acrylic colours and applied to the surface, or used alone and then overpainted. The raised texture can be moulded into different shapes when wet, or cut or carved when dry. Textural paste is ideal for mixed media work, collages, and imprinting, as you can mix in different materials, such as sand, beads, or flakes. In this coastal landscape (*left*), the flowers in the foreground were moulded with paste and then painted, creating a fresh and exciting texture.

The painting's texture flattens out as it recedes into the background; the grasses mark a mid-point in distance and texture.

The bold texture of the flowers in the foreground lends realism to the painting and adds drama to the landscape.

Thinned paint blends naturally when painted wet on wet.

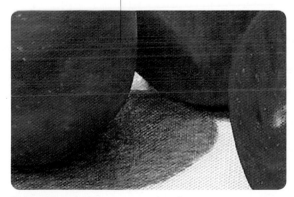

Using thin paint There are several mediums you can use to increase the fluidity of acrylic paints. Flow improvers are designed to enhance the paint's fluidity without diluting its colour, so the paint becomes thinner but remains vibrant. The effect is similar to fluid paints (*see opposite*). You can also lengthen the drying time, to increase the paint's workability, by adding retarder medium. For fine glazes, use a glazing medium, which thins the paint, leaves no brushstrokes on the surface, and dries very quickly, allowing you to paint layers rapidly.

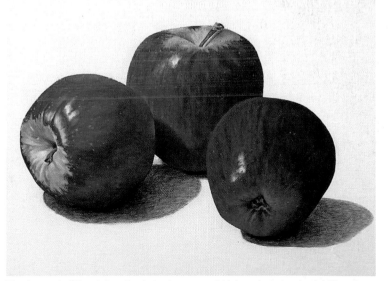

Fine layers In this painting, the darker tones were laid down in dark red paint. Many fine layers of thin paint in lighter reds were then added to create the apples' glossy skin. The green areas around the stalks were added in a thicker paint for contrasting texture.

Developing colour

Colours and tones are vital considerations when planning and executing a painting. Think about your palette as you consider your subject, and allow the mood and style of the painting to influence your colour decisions. Are you looking for a subtle or vibrant effect? Do you need to use colour to establish focal points? Think about the interplay of colour across the painting before selecting a palette.

ESSENTIAL PALETTE

Colour mixing is a learned art, and one that develops with practice. Start by using a fairly limited number of paint colours and experiment with mixing. Try darkening or lightening your paints with colours other than black and white. This will have the effect of warming or cooling your original colour at the same time as changing its tonal value.

 Titanium white
 Lemon yellow
 Naples yellow
 Yellow ochre
 Raw sienna
 Mars violet

 Burnt umber
 Payne's grey
 Permanent sap green
 Cobalt blue
 Pyrrole red light
 Permanent alizarin crimson

CONTEMPORARY PALETTE

One way to give a painting a more contemporary feel is to select bright colours and use them largely unmixed and unblended. The range of paints shown here would work well as unmixed colour blocks; of course, they could also be mixed to achieve a broad spectrum of hues. You may also wish to consider using specialist paints, such as metallics or iridescents.

 Titanium white
 Lemon yellow
 Cadmium yellow medium
 Benzimidazolone orange
 Pyrrole red light
 Permanent alizarin crimson

 Quinacridone magenta
Dioxazine purple
 Cobalt blue
Indanthrene blue
Cobalt turquoise
Cobalt green deep

ADDING BLACK AND WHITE

Adding black or white would seem to be the simplest way to darken or lighten a colour. However, remember that this may also change the paint hue. When black is added to yellow, it makes green (*see right*); red turns brown, and green shifts towards blue. Adding white produces a tint of the original colour and increases its opacity, but it also reduces the colour's brightness, so the resulting colour is less vibrant than the original.

Mixing with black and white Black darkens but muddies colour, sometimes changing a colour's essential hue. White lightens colours by making them more opaque.

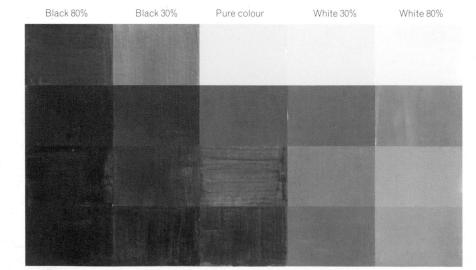

Black 80% Black 30% Pure colour White 30% White 80%

USING COMPLEMENTARY COLOURS

Complementary colours are those that sit opposite each other on the colour wheel – for example red/green, orange/blue, and violet/yellow. Used side by side in a painting, complementary colours intensify one another, creating a lively contrast. When you mix a hue with a little of its complementary colour, the result is a richer dark shade than can be achieved by adding black. Mixing together complementary colours can produce wonderfully subtle, neutral colours, which can be steered towards warmer or cooler hues.

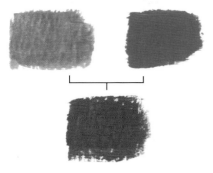

Red and green These colours produce a rich, chocolatey brown. Red and green mixes always produce the warmest form of neutral colour.

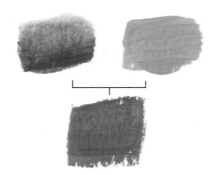

Blue and orange This cooler, darker neutral is a useful green base for painting shaded areas, especially in landscapes.

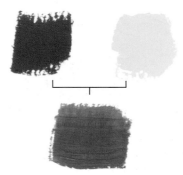

Violet and yellow These complementaries mix together to form a soft neutral that is useful for flesh tones. Darken or cool with brilliant purple.

FOCUS ON COLOUR

Colour plays many roles within a painting. It can mark out a focal point, lead the eye through a painting, create perspective, add realism or express emotion. Colour changes dramatically with light, and it is this relationship that informs tone and vibrancy, and ultimately the overall mood.

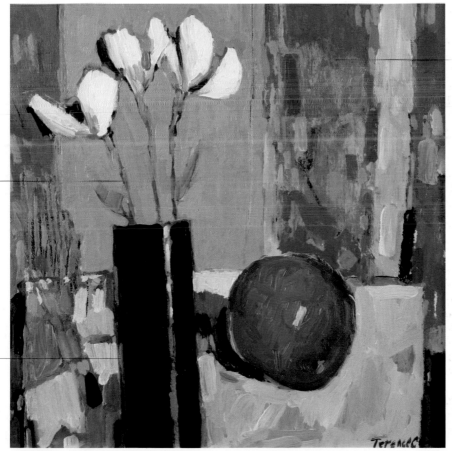

The strong monochrome contrast between the white flowers and black vase positions it firmly as the focal point of the painting.

Coloured highlights bring the dark vase to life.

The fabric of the curtain creates a multi-coloured frame for the vase in the foreground. The orange shape balances the orange fruit on the table.

Colourful composition
The use of vibrant colour indicates that this picture is filled with light. Simple shapes combine with bold colour to create a beautifully balanced composition and an expressive still life.

Groundwork

When you have chosen your subject, explore how to tackle it through a series of sketches. Play with viewpoint, perspective, context, and lighting; experiment with space and the relationship of the subject to the edges of the paper or canvas until you arrive at a workable composition. Examine the colours in your scene, and consider laying down a coloured ground to unify and enrich your painting.

COMPOSITIONAL SKETCHES

For most artists, sketching is the critical first step of a new work. Sketches help you develop an idea – to identify where the interest of a scene lies so that you can decide what to put in and what to leave out. Sketching allows you to explore composition, format, and framing before you commit paint to canvas. Consider as many compositional possibilities as you can and try not to make judgements too early in the process – happy accidents can produce great results. Work fast and loose, always starting with the larger masses of your subject.

Tonal drawings Start by sketching shapes to help you choose between possible elements and views. Make tonal sketches using quick monochrome mediums, such as pencil (*above left*), charcoal, or ink (*above right*).

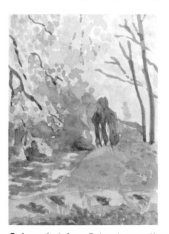

Colour sketches Colour is more than mere embellishment; it plays a structural role in many compositions. Similarities of colour can connect or separate areas of the painting; colours can reinforce spatial depth, and set up patterns or structures. Though it is possible to make colour sketches in acrylics on location, many favour a more portable set of watercolours or pastels for this purpose.

The final sketch Choose the composition that you feel is most successful, and work this up into a larger, more detailed colour sketch in pencil, ink, pastel, watercolour, acrylic, or a mixture of these mediums. Mix some spots in acrylic to capture key colours from the scene; note the composition of these mixes – it will be very useful once you are back in the studio. Make sure that you have recorded all the key shapes, colours, and tones in the scene.

SKETCHING WITH PAINT

Some artists prefer the immediacy and looseness of working directly with paint on canvas, omitting the sketching stage. If you want to try this, concentrate on the basic shapes of the objects in the scene first, and work on the whole painting at once; this will prevent you from getting bogged down in detail before the composition is resolved.

1 Shape If you wish to work on a coloured ground, paint the support and allow this to dry before starting your paint sketch. Establish outlines of the basic shapes in loose brushstrokes, working in light-coloured, thin paint.

2 Form Add the light and medium tones of your painting, so the shapes begin to take on form and dimension.

Leave any detailing, such as painting the rim of this cup, until last, to create a perfect balance.

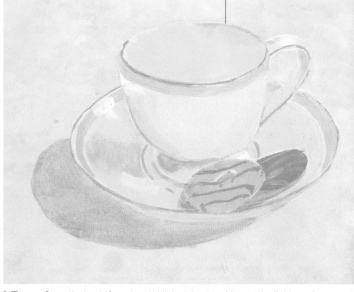

3 Tones Once the basic form is established, begin adding in the lights and darks, taking account of light source and direction. Pay close attention to the positions of any highlights and to the subtleties of tone – the inside of the cup is a darker tone than the outside, but the shadow on the saucer and the table are deeper still. Paint details last, so that the colours and tones used are sympathetic to the body of the composition.

USING A COLOURED GROUND

Many painting supports, such as paper or canvas, are white or off white in colour. However, painting on white can result in a hesitant use of colour because almost every colour seems too vivid against such a stark background. For this reason, many artists prefer to work against a mid-toned, coloured background, which makes it easier to judge colour values. Coloured grounds have other benefits: for example, revealing patches of colour across a landscape can help tie a scene together, uniting sea and sky.

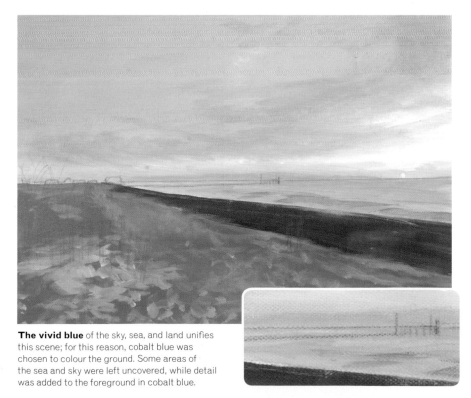

The vivid blue of the sky, sea, and land unifies this scene; for this reason, cobalt blue was chosen to colour the ground. Some areas of the sea and sky were left uncovered, while detail was added to the foreground in cobalt blue.

Essential techniques

Acrylics can be used in a great variety of ways, even straight out of the tube. Some artists like to work precisely in this way, producing wonderful pieces with a characteristic solid, opaque feel. But the real beauty of acrylics is their versatility: different tools and techniques produce a huge range of paint effects. Described below are just a few of the most common and useful methods to get you started.

IMPASTO

This technique is used to apply thick layers of paint straight from the tube, retaining brushstrokes and marks. It adds texture to the surface of your painting in a tangible way, increasing depth and providing focus.

Tools and materials: Use modelling paste, matt or gloss gel medium, or paint straight from the tube. Apply the paint or paste using a palette knife or a stiff bright brush.

For thick texture over a large area of your picture, use a palette knife to apply modelling paste before you start painting. This can be sanded or shaped and painted once dry.

For intricate, natural texture, mix some gel medium into your paint. Apply with the flat surface of a palette knife; lift away the knife and let the suction shape the paint mixture into organic peaks.

GLAZING

This technique is used to apply thin, transparent colour over an existing layer of dry colour, leaving no visible brushmarks. Glazing modifies or intensifies colour and adds depth to the painting.

Tools and materials: Mix your paint with gloss or matt medium, flow improver, or water. The use of a medium will extend drying time and provide a more vibrant finish. Use a large, soft, flat brush to apply the paint.

Thin down your paint to achieve a transparent colour, using water or an appropriate medium (*see left*). Apply the paint using smooth, wide strokes to ensure an even finish.

Glazing can be used to alter the colour of existing layers of paint, as seen here on the leaves. Glazing is great for producing realistic shadows and for suggesting translucency.

SCUMBLING

This technique is used to apply an uneven layer of paint over an existing layer. It can be used as a correctional technique to knock back vivid colour, or it can be performed several times to create areas of complex texture and colour.

Tools and materials: Apply the paint unevenly, in a scrubbing motion, using a stiff brush or rag. No mediums are necessary for this technique.

Load the brush with a small amount of paint and apply it to the surface using a rubbing or scrubbing motion. Work unevenly, applying more paint into the areas which require most colour.

If you use scumbling on a painting in which some layers have dried but others remain wet, the wet layers will blend with the scumble colour in some areas and lift away with it in others.

WET ON WET

This technique is used to apply one layer of paint over an existing still-wet layer beneath. The colours are able to run and blend together, producing soft shapes that lack hard edges or focus. The technique is particularly useful for organic forms.

Tools and materials: Mix your paint with water, flow improver, retarder, or gloss or matt medium to ensure that it stays wet during application. Consider using an atomiser to spray the surface with water from time to time. Apply the paint using any brush.

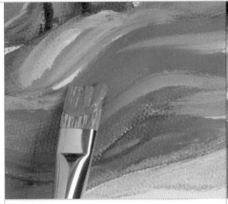

Wet your support with a spray atomiser or brush. Mix your paint with an appropriate medium (*see left*), then apply the first colour. Continue with successive layers of paint.

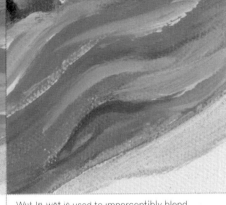

Wet-in-wet is used to imperceptibly blend together colours or tones. The mediums used allow the paint to remain workable for longer, so you can blend – or not – exactly where you wish.

SPATTERING

In this technique, paint is flicked on to the surface to create random dots of colour. It is used to add interest or to suggest detail or movement. Complex layers of texture and colour can be built up in this way.

Tools and materials: Use a stiff brush or a toothbrush to spatter paint over smaller areas, and a larger brush or atomiser for wider areas. No medium is necessary for this technique. Use sheets of waste paper to protect other areas of the picture from accidental spattering. Thin the paint to be spattered with water or flow improver. Experiment with paint consistency and loading for the best effect.

Load a round brush with thinned paint and throw the paint on to the surface. Alternatively, dip the bristles of a toothbrush into paint, then flick them with your finger to spatter paint on to the support

Splashes of opposing colours enliven the painting and add interest to larger areas of flat colour. The technique is used here to suggest movement, by depicting muddy water flying up from the ground.

DRY BRUSHING

This technique is used to add a fine, uneven layer of paint over certain areas of a painting to achieve a feathered textural effect. It can be used to build layers of subtle tones and colours, to break up flat, uninteresting areas of colour, or to suggest detail – especially in fur, grass, and fabric.

Tools and materials: Choose a stiff brush that will make the required edge marks: flats for flat edges, fan brushes for wide arcs, and round brushes for points. No medium is necessary for this technique.

Load a brush with a small amount of paint. Wipe most of the paint from the fibres before applying the "dry" brush in short movements that leave irregular, fibrous marks.

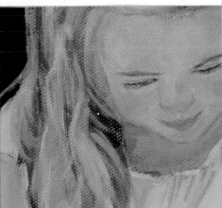

Dry brushing is a very effective technique for painting hair. By dry brushing in several layers in a palette of related colours, you can build up finely-textured layers.

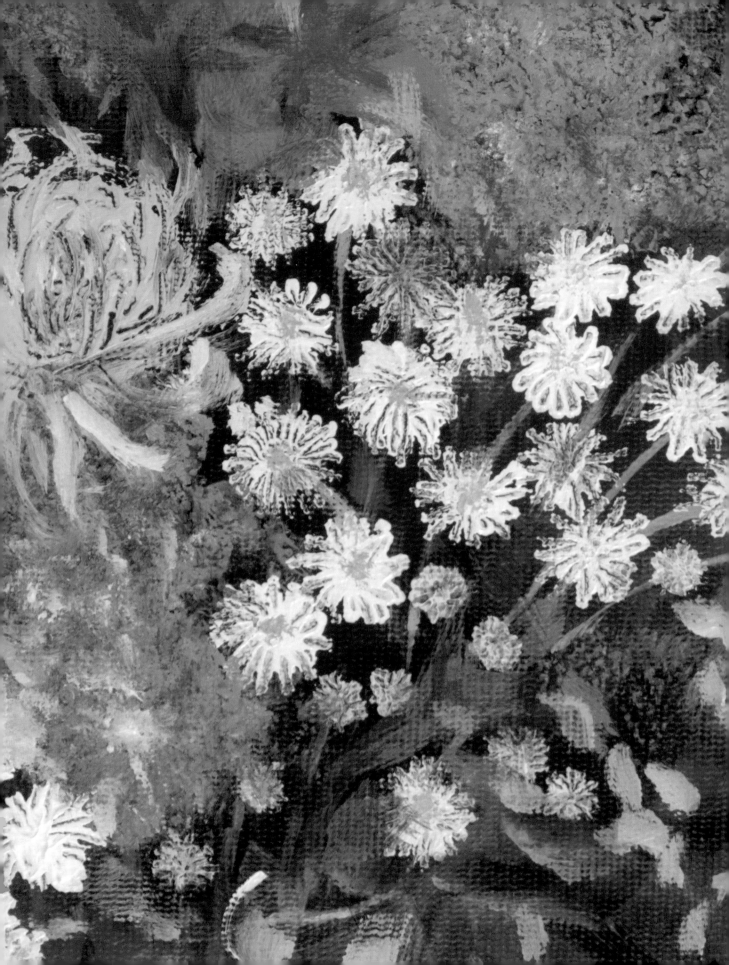

Still Life

"Look for the stillness and serenity that lies hidden in everyday objects."

Composition and focus

A well-composed painting feels balanced and structured, with harmonious links between the objects. Aim to create a strong focal point for the painting and plot a visual pathway that leads the viewer's eye through the other elements in the composition using line, tone, and colour as signposts. When making compositional decisions, simplify as much as possible, retaining only essential elements.

USING A GRID VIEWFINDER

A viewfinder is a useful tool for analysing a composition when sketching from life. First, it isolates and frames the subject, allowing a more objective assessment of the balance of shape, tone, and colour. Its grid of cotton threads helps you to position the elements on your sketch for accurate perspective. The grid can be a regular repeated array of threads, or a simpler division into thirds (*see right*) that you can use to guide the composition. It is easy to make your own viewfinder from cardboard and thread.

The cotton threads form a grid which can be easily translated on to a surface.

Use the grid to establish relative positions and sizes of objects.

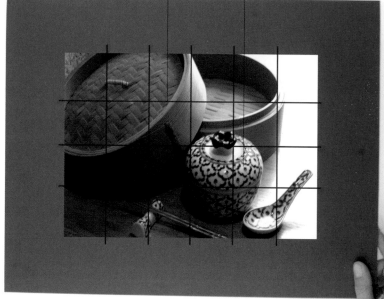

1 Hold the viewfinder up to your subject, and experiment with different arrangements and points of view until you feel happy with the composition.

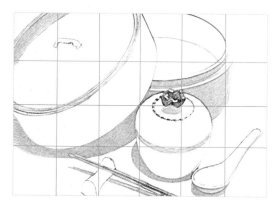

2 Mark out the same grid on your support using a ruler and pencil, and sketch in the viewed image frame-by-frame, as divided by the grid. In this way you can transfer the viewed image accurately and to scale.

The viewfinder grid makes it easy to establish positions and shapes of shadows and highlights.

The baskets and table were painted in lighter tones to place more emphasis on the pot as the focal point.

3 The final image reflects the original composition, but the artist has played with tones, and altered details to add interest. The jaunty angle of the pot lid and a more high key approach to the light create a warm, light-drenched painting.

THE RULE OF THIRDS

A traditional way to produce a balanced composition is to call on the rule of thirds. The rule states that a picture will have more interest if the focal points are arranged one third of the way across or down the surface, than if they are arranged centrally or peripherally. This may be because central compositions are "at rest" and so demand no further exploration, while compositions in thirds have intrigue – but not so much as to be unsettling.

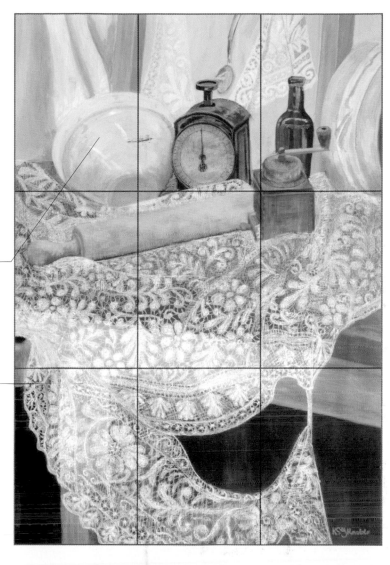

Equilibrium is encouraged in this painting by grouping several elements on a common axis.

The edge of the wooden table follows a "rule of thirds" axis.

To use the rule of thirds in your compositions, divide your painting surface into thirds and then place the main points of interest where the lines intersect.

Painting in thirds This painting is clearly divided into thirds. Notice how the negative space beneath the table balances the objects in the uppermost third of the painting.

COLOUR FOR COMPOSITION

The eye perceives cool colours (blues and greens) as being further away than warm colours (reds and yellows). For this reason, you can use contrasts of warm and cool colours to create an illusion of depth and define perspective. Colour can also be used to catch the eye: small splashes of bold, vibrant colour in a low-contrast painting will attract interest. Areas of the same colour will naturally link objects, and help to create a flow around the painting.

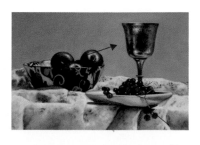

The luminous red of the currants and the apples leads our eye up and towards the tall goblet, placed on an intersection of thirds for perfect balance.

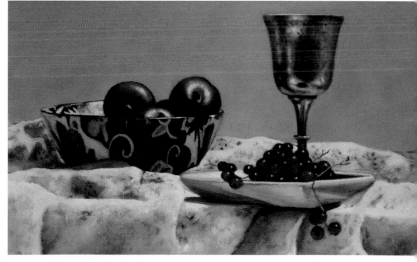

Triangular composition This painting makes brilliant use of the full range of tones available across a limited palette to create a realistic variety of surfaces. The colours and triangular composition of the central features draw the eye in and around the picture.

Light and shade

Tone is a vital ingredient in an effective painting; it creates atmosphere, establishes focal points, and gives objects realistic shape and depth. Before you paint, consider the quality of light illuminating your scene – strong, directional light will give extremes of tone, and the high contrast will create immediate drama. However, a work can be just as successful when lit with soft, diffused light that creates only a narrow range of tones. A low contrast picture can summon up a contemplative mood, for example.

USING CONTRAST

When planning a painting, consider both the breadth of tones in your scene and how they are arranged relative to one another – it sometimes helps to squint at the scene to pick out the different tones. Try to balance tones across the composition to prevent it appearing lopsided and jarring. Placing light and dark tones next to one another helps to differentiate forms, and locating these sharp contrasts at the focal points of the composition will boost the energy of the image. Remember to assess tones relative to adjacent tones rather than in absolute terms – a dark grey, for example, may appear relatively very bright when butted up against pure black.

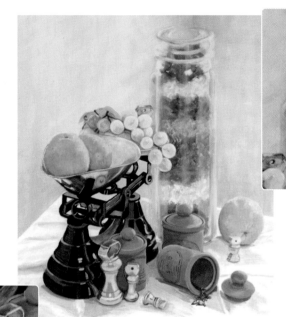

Carefully rendered tones in this painting mean that the jar's form is held, even when colour is removed.

Power of contrast Strong tonal contrasts and sharp highlights give the painting immediate energy. They create the impression of detail, which pushes the elements – the weight and scales – forwards in the composition.

The folds of the tablecloth are described by gentle tones, rather than by lines, which contributes to the natural feel of the painting.

The light source for this painting is located to the above right of the arrangement. Directional but diffuse, it provides good modelling for this still life.

LIGHT AND SHADE FOR FORM

Tone is a record of the intensity of light reflected by an object. It is what gives an object its shape. This outline is simply flat and round and makes no suggestion of 3D form.	Filling the shape with colour makes the circle appear more solid. It begins to have mass – to suggest a tomato, perhaps – but it still appears flat, as though floating on the page.	The addition of a shadow below and to the right of the red disc immediately suggests its depth and volume, though its precise form still remains unresolved and ambiguous.	Only when you build the tones does the tomato's shape begin to emerge. Light orange tones and highlights to the left and centre, and dark red shadow to the lower right provide modelling.	Defining form with tones has turned the circle into an irregular sphere. The addition of the vivid green stem, and its shadow on the curved red surface, completes the tomato.

THE COLOURS OF LIGHT

The light illuminating a scene is rarely pure white, and using white paint in your work will leach feeling and liveliness from a painting. Instead, examine the colour of your light source – the warm gold of a fire, the purplish-red of a setting sun – and ensure that these colours are apparent in the whole scene. Surfaces will all be tinged with the colour of the incident light, and highlights will appear not as pure white, but carrying a faint trace of the colour. Shadows too are rarely just an absence of colour, but are tinged with the ambient light that leaks into the shadow areas. Outdoors, this is usually a blue colour – the illumination from the sky – but it can equally be a tint reflected from within the scene.

PAINTING LIGHT

Titanium white + Mars violet

Titanium white + Naples yellow

Titanium white + cobalt blue

Use tiny amounts of colour from your palette to mix with titanium white, so that the "white" you use has a subtle blend of other colours in your painting. The colours above are good starting points for a warm light, a golden light, or a cool light (*left to right*).

PAINTING SHADE

Payne's grey + cobalt blue

Payne's grey + Mars violet

Payne's grey + Naples yellow

Use an array of colours from your palette mixed with blues and darks to emulate shade and shadows falling on or behind objects. This will help to create a unity and continuity of colour over the whole picture.

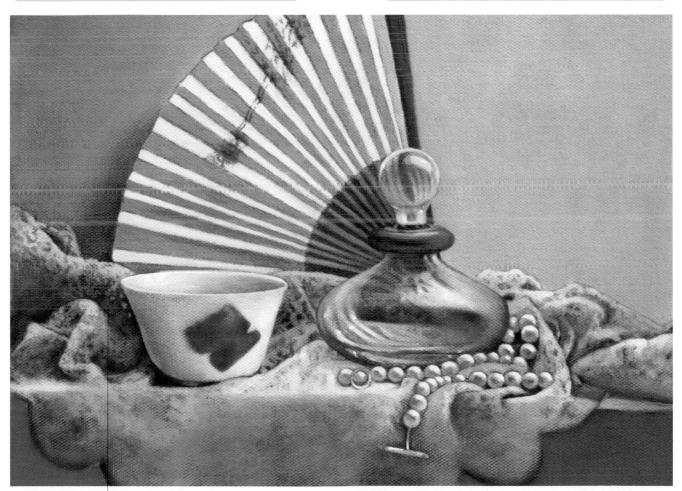

The almost tangible texture of this woollen shawl has been created entirely through controlled use of tone.

Creating a mood White and transparent surfaces reflect the gentle blues and greys of the objects around them in cool tones to create a soothing mood in this painting. The warm brown of the fan's stem adds a vital focal point.

Gallery

The versatility of acrylics enables you to approach painting still life in a wide variety of ways, encouraging experimentation with expression.

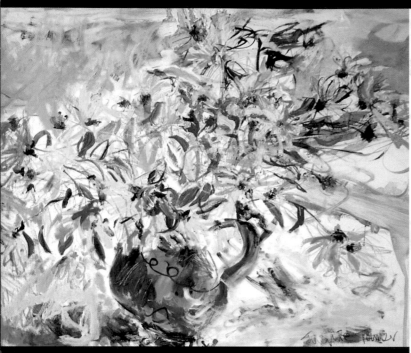

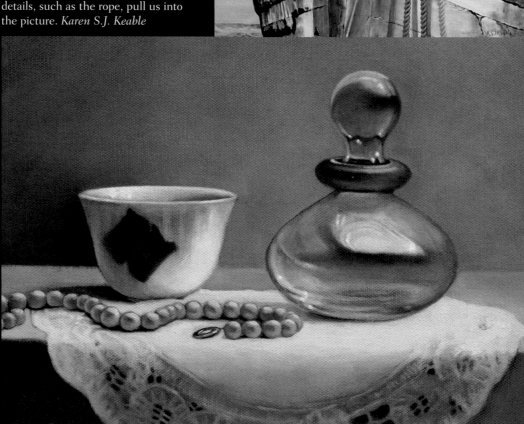

▲ Yellow Daisies III

The play of yellow against the blue background of this painting creates a riot of colour, which moves us around the scene. The loose brushmarks bring the brilliant flowers to life. *Jacquie Turner*

Big Red ▶

This powerful subject has been strengthened further through a dynamic perspective and the use of red, while details, such as the rope, pull us into the picture. *Karen S.J. Keable*

Perfume Bottle, Bowl, and Pearls ▶

This painting makes brilliant use of the full range of tones available across a limited palette to create a realistic variety of surfaces. The colours and triangular composition of the central features work to draw the eye in and around the picture. *Dianne Urwin*

◄ Reserve
Collection
(*far left*)
This painting perfectly demonstrates the strengths of unity as a compositional device, where the form of the focal point echoes throughout the painting. *Barry Atherton*

◄ Tea with
Mavis (*left*)
The open doors invite us into the cosy interior of this still life; the doors frame the still life within the landscape. *Karen S.J. Keable*

◄ Red Tulips
with Pink Chair
The bold use of colour here works to distinguish background and foreground in a dramatic way. The rigid lines of the furniture contrast well with the fluid lines of the flowers, which flow in an arc over the painting.
Terence Clarke

1 Bottles and jars

Cool blues and greens unify this careful composition of bottles on a window ledge. The painting explores the interaction of light with glass. The strong illumination from behind, filtered through the fresh green of trees, passes through the bottles, lighting them from within; this translucency is captured through successive washes of colour. The background, distorted through the curved glass of the bottles, requires close observation; capturing this distortion accurately is key to giving the bottles believable form.

EQUIPMENT
- Stretched canvas
- Brushes: No. 16, No. 4, No. 9, No. 12 flat
- Ruler and sea sponge
- Permanent sap green, lemon yellow, cobalt green deep, permanent green light, titanium white, cobalt blue, cobalt turquoise, Payne's grey, Naples yellow, phthalo turquoise

TECHNIQUES
- Sponging

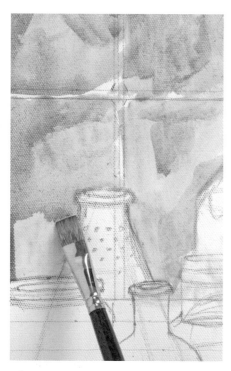

1 Create an atmospheric, defocused background for the bottles. Start by mixing permanent sap green with lemon yellow; lay down blocks of this colour, keeping the No. 16 brush well wetted as you work.

2 Mix a darker hue of sap green and cobalt green deep and apply in watery blocks as before, allowing the colours to run into one another. Add still more cobalt green deep and repeat for a mottled tone. Work quickly; if the acrylic paints are allowed to dry, the result will be unrefined and blotchy.

BUILDING THE IMAGE

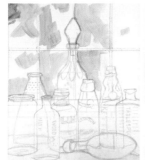

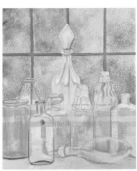

3 Moisten a natural sea sponge with water, and dip into a mixture of permanent green light and lemon yellow. Dab the paint lightly and irregularly over the painted background. Add plenty of titanium white to the mix, and repeat the sponging over the background.

4 Continue sponging with a mixture of cobalt blue and cobalt turquoise added to the paint from Step 3. Use this darker mix very sparingly to complete the mottled background – if you apply the paint too heavily, simply use your finger to smudge it back.

5 Work precisely on the leaded window behind the bottles. Mix together Payne's grey, cobalt blue, permanent sap green, and titanium white and paint the leading with the No. 4 brush. Use a ruler to keep the lines tidy and ensure the paint is pasty in texture – too watery and it will leach out. Indicate the leading behind the bottles with looser strokes.

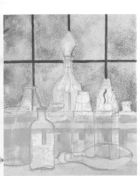

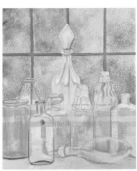

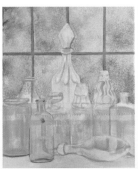

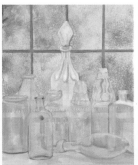

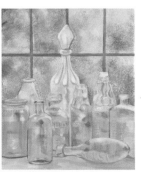

6 Establish the form and colour of the window frame and the sill on which the bottles sit. Use the No. 9 brush with a mix of titanium white, cobalt blue, Naples yellow, and a little sap green. Paint the frame as you see it – its lines distorted by the refraction of the light through the bottles. Next add the parts of the sill directly illuminated through the window with Naples yellow, titanium white, and a little of the darker mixture.

"Glazing can bring glass alive with subtle shadings."

7 Begin painting over the green glass bottles with the No. 12 brush carrying a wash of cobalt turquoise mixed with titanium white. Work over the top of any paint beneath with bold vertical strokes; note how the underlying colour is modified by application of the wash.

8 Emphasize the raised lettering on the glass bottles, which has been partly obscured by the application of the wash. Use titanium white applied with the tip of the No. 9 brush to lift the characters above the surface.

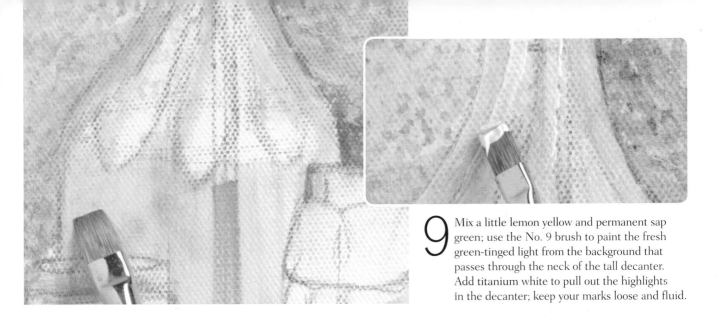

9 Mix a little lemon yellow and permanent sap green; use the No. 9 brush to paint the fresh green-tinged light from the background that passes through the neck of the tall decanter. Add titanium white to pull out the highlights in the decanter; keep your marks loose and fluid.

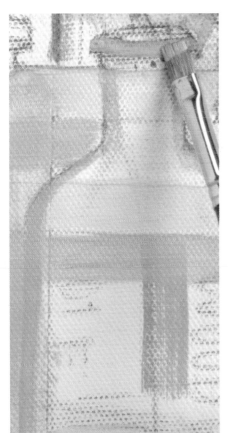

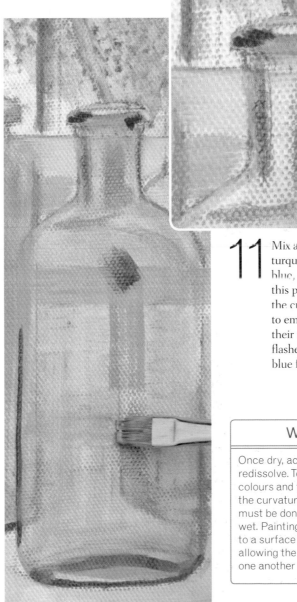

11 Mix a lively blue wash of cobalt turquoise, lemon yellow, cobalt blue, and titanium white. Drag this paint with a No. 9 brush along the curves of the blue glass vessels to emphasize their shapes and their reflective qualities. Add flashes of Payne's grey and cobalt blue for the darkest areas.

10 Make a mixture of cobalt blue and titanium white, and use the No. 4 brush to boldly mark the outer edges of the blue glass bottles and jars. Examine the subject carefully to catch the nuances of reflection and refraction; note for example, how the thickness of the glass effectively increases towards the edges of a curved surface.

WET ON WET

Once dry, acrylics cannot be made to redissolve. To produce the continuous colours and tones needed to represent the curvature of a bottle, all blending must be done while the paint remains wet. Painting a wash of one colour on to a surface that is already wet and allowing the colours to diffuse into one another is known as "wet on wet".

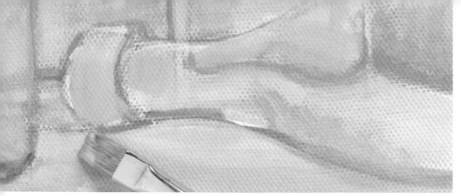

12 Add some titanium white and lemon yellow to the light paint mixed in Step 11 and continue adding the mid-tones of the bottles, working in thick, broad strokes. Paint the coloured shadows cast by the bottles, pausing regularly to review colours and tonal values.

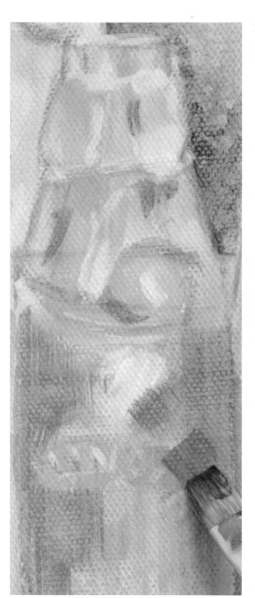

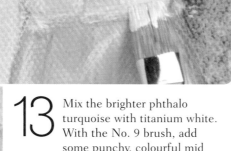

13 Mix the brighter phthalo turquoise with titanium white. With the No. 9 brush, add some punchy, colourful mid tones. Add a little of this colour to titanium white and paint the highlights.

14 Mix a wash of Payne's grey and cobalt blue. With the No. 9 brush, add loose dark marks into the background foliage and at the margins of the bottles to represent uneven refraction of light; blend with a fingertip.

15 Finish the painting by reinforcing the lightest and darkest tones. Use titanium white with a speck of Naples yellow to add patches of white light on the windows – this gives them a true reflective quality. Use the same broad No. 12 brush to apply dark accents to the bottles and the background. Keep these marks loose and textural.

Bottles and jars ▶

The soft sponged background complements the delicate forms of the bottles on the window ledge, which are composed to lead the eye upwards. The result is an airy, calming image that is a study in the way light is reflected and refracted by thick glass.

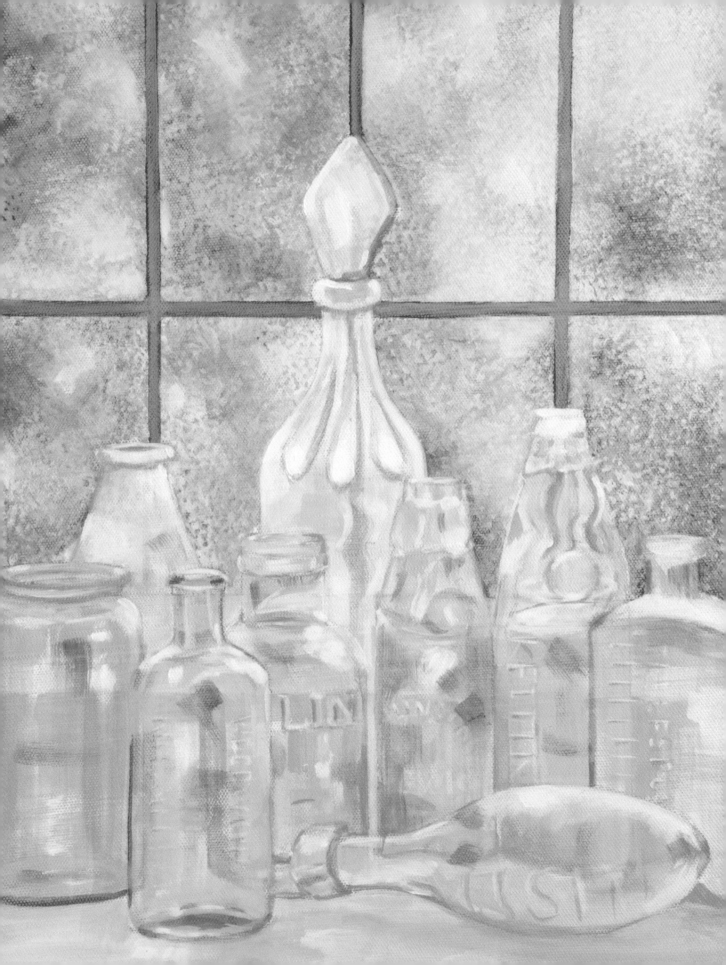

2 Flowers in a vase

A loose arrangement of bright flowers lends itself to a spontaneous painting in which the leaf and flower forms are sketched with a brush rather than a pencil, or even created by the impression of plastic film or scraper. The composition has an almost photographic immediacy – with the flowers cropped at the edge of the canvas – suggesting a world beyond the painting. The simple dark, dramatic background adds intriguing depth to the composition and helps throw the dazzling flowers towards the viewer.

EQUIPMENT
- Stretched canvas
- Large watercolour brush
- Brushes: No. 2, No. 4, No. 6, No.8, No. 14 flat; No. 4, No. 6 round; fan blender
- Plastic scraper
- Palette knife
- Plastic wrap and sponge
- Indanthrene blue, cobalt blue, titanium white, Payne's grey, Naples yellow, transparent yellow, permanent sap green, cobalt green deep, permanent alizarin crimson, pyrrole red light, cobalt green light, Mars violet

TECHNIQUES
- Plastic wrap texturing
- Scraping
- Impasto

1 Use a large watercolour brush to block in the background with a mix of indanthrene blue, cobalt blue, titanium white, and Payne's grey. Add more indanthrene blue and Payne's grey to the mix to darken the area immediately behind the flowers.

2 Sketch in the outline of the vase using the edge of the No. 8 flat brush. This helps to position the floral and foliage elements. Block in the white tablecloth with a mix of Naples yellow and titanium white.

3 Pick up a mixture of transparent yellow, permanent sap green, indanthrene blue, and cobalt green deep on the No. 14 flat brush. Paint the leaves by pressing the brush down, then twisting and releasing pressure.

BUILDING THE IMAGE

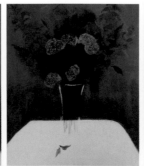
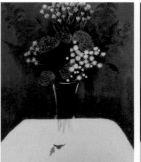
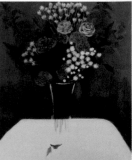

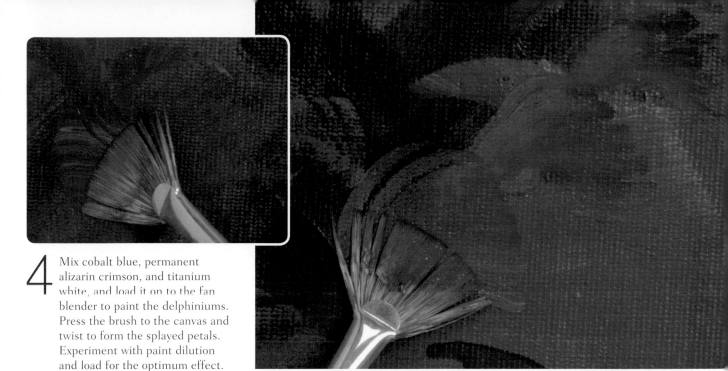

4 Mix cobalt blue, permanent alizarin crimson, and titanium white, and load it on to the fan blender to paint the delphiniums. Press the brush to the canvas and twist to form the splayed petals. Experiment with paint dilution and load for the optimum effect.

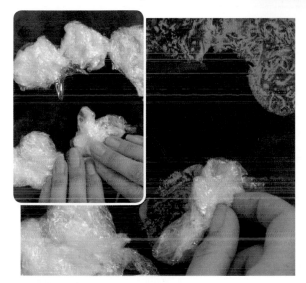

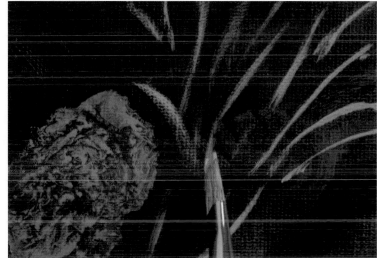

5 Add titanium white and water to the mix from Step 4. Use the No. 14 flat brush to paint the shapes of the lilac flowers, and then press crumpled plastic wrap on to the painted areas. Wait for one minute before lifting off the plastic wrap.

6 Establish the small white daisies at the top of the painting to set out the top of the composition. First paint their stems using a mix of cobalt green deep, Naples yellow, and titanium white. Use the edge of the No. 6 flat brush for well-defined lines.

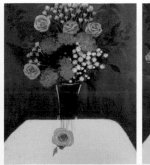
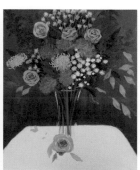
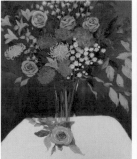
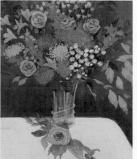
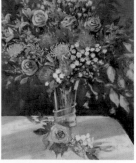

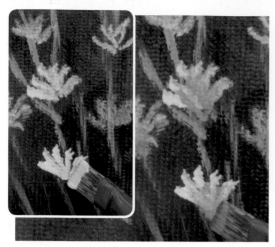

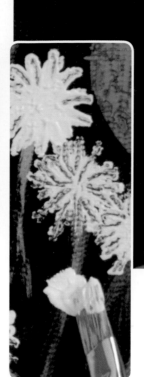

7 Paint the petals with pure titanium white applied with the No. 8 flat brush. Use just the tip of the brush to make linear marks in a whorl shape. Mix cobalt green deep with Naples yellow, then use the same brush to add green bracts under the petals – these are most evident on the flowers viewed from beneath.

8 Create the white flowers lower in the picture by painting thick circles of titanium white on to the canvas with the No. 8 flat brush. Use a rounded plastic scraper – a chopstick will do – to push and mould the paint into the shapes of the petals. This technique gives the floral forms texture and so pushes them forward.

9 Mix permanent alizarin crimson, pyrrole red light, and cobalt blue with a little titanium white. Apply this colour using the No. 14 flat brush to set out the basic underlying form of the pink roses. The dark tones will still be visible in the finished painting as the deep shadowed folds between the roses' petals.

10 Add titanium white to the colour mixed in Step 9 to make a light pink. Load the paint on to the No. 14 flat brush and work outwards from the centre of the flower while the darker underlying paint is still wet. Refine and soften the marks using the No. 6 round brush, then blend the darker and lighter areas.

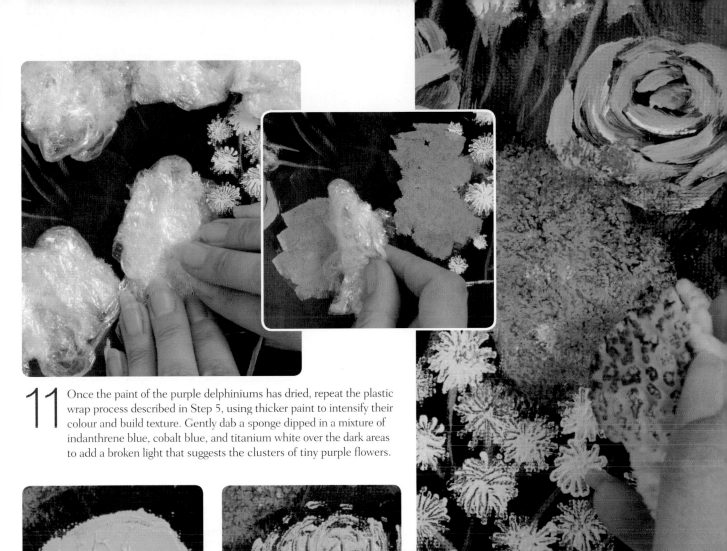

11 Once the paint of the purple delphiniums has dried, repeat the plastic wrap process described in Step 5, using thicker paint to intensify their colour and build texture. Gently dab a sponge dipped in a mixture of indanthrene blue, cobalt blue, and titanium white over the dark areas to add a broken light that suggests the clusters of tiny purple flowers.

"Use uneven colour mixes to suggest the natural textures of flowers."

12 Make a smooth mixture of cobalt green deep, Naples yellow, and titanium white. Apply this paint with a palette knife, spreading it thickly to delineate the green chrysanthemums. Use the plastic scraper to move and remove the paint until you have formed the flower shapes. Add some stray outer petals using the No. 6 round brush and then scrape back for texture.

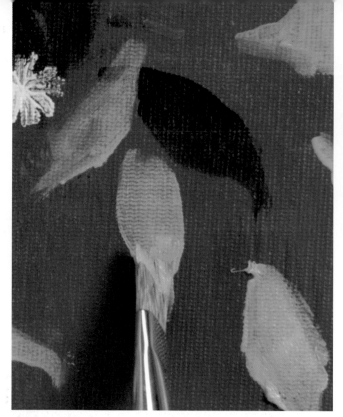

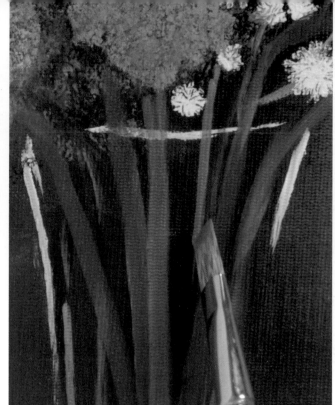

13 Use the paint mixed for Step 12 to shape the beech leaves that lie to the right of the arrangement. The bright colour of these leaves will help to balance the presence of the green chrysanthemums to the left of the composition. Use the No. 8 flat brush and the twisting technique used in Step 3 to form the leaves. Add some cobalt blue to the mix to paint the darker, shadowed leaves.

14 Use a mixture of cobalt green light, Naples yellow, titanium white, and cobalt blue to paint the stems of the flowers visible through the clear glass of the vase. The No. 14 flat brush used on its edge is perfect for this task.

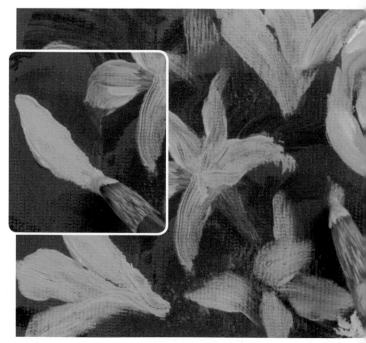

15 Use the No. 14 flat brush and the colour mix from Step 14 to paint the leaf that falls over the rim of the vase, and the leaves of the rose lying below the arrangement. Add gestural marks behind the foreground leaves to suggest the presence of more distant foliage.

16 Blend transparent yellow, pyrrole red light, and a little Naples yellow to enhance the thickness of the paint mix for the yellow lilies. Use a No. 6 round brush to press the paint on to the surface in a thick line before gradually releasing the pressure to form a tapering petal shape.

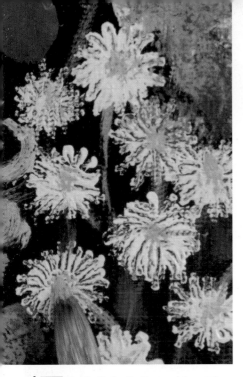

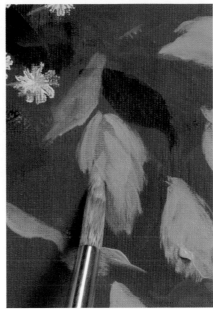

19 Add some indanthrene blue into the green paint mix and use it to paint ribs on to the leaves using the smaller No. 4 round brush. The detail in these leaves makes them appear closer to the viewer.

17 Add a little titanium white to the green tone mixed in Step 14. Stipple this on to the centres of the small daisies with the No. 6 round brush. Use the same colour to add stippling over the purple delphiniums to suggest their green flower parts and add texture.

18 Mix a little Naples yellow into the green used in Step 17 and use it to brighten and strengthen the leaves on the right-hand side of the painting. This helps to balance the composition.

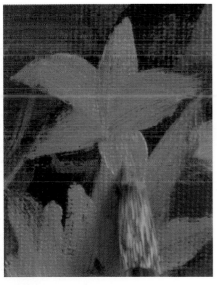

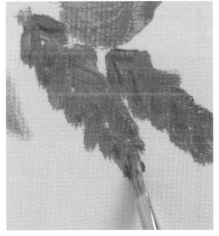

20 Mix the bright pink colour of the gladioli from permanent alizarin crimson, pyrrole red light, and titanium white. Apply paint using the No. 6 round brush, pressing it down to form a line before lifting it away in a twisting, tapering motion.

21 Refine the composition by adding to the foreground. Paint the grape-like petals of the lavender flowers on the table in a rough mix of indanthrene blue, cobalt blue, and titanium white, using a No. 2 flat brush. Consider the balance of the composition, and if necessary, add more leaves to the rose on the table. You may also want to extend the pale tone of the tablecloth.

22 Use a No. 8 flat brush loaded with a mix of titanium white and Naples yellow to establish the right edge of the vase and pick out the decorative glass spirals down its length. Dry brush pure titanium white in horizontal lines down the vase using the broad side of the brush to create the translucent, reflective surface of the glass.

23
Add speckling detail to the yellow lilies using Mars violet applied with a fine No. 4 flat brush. Coarsely mix some pyrrole red light into the mix and paint stamens into the centre of each flower.

24
Add detail and depth to the gladioli by painting their centres with a mix of pyrrole red light and permanent alizarin crimson. Add some white to the mix and use this to give highlights on the petals.

25
Fleck the beech leaves with highlight colours to bring their glossy surfaces to life. Use a mixture of titanium white and Naples yellow for the brightest lights, adding these selectively to give the leaves dynamic range.

26
Add titanium white and Naples yellow highlights to the top right-hand side of the vase. Finally, use the wide No. 14 flat brush to apply a watery glaze of indanthrene blue and Payne's grey across the shadowed area of the tablecloth.

Flowers in a vase ▶

Carefully balanced composition, with symmetry in the tones and colours of the flowers and foliage, adds order to this joyfully kaleidoscopic painting.

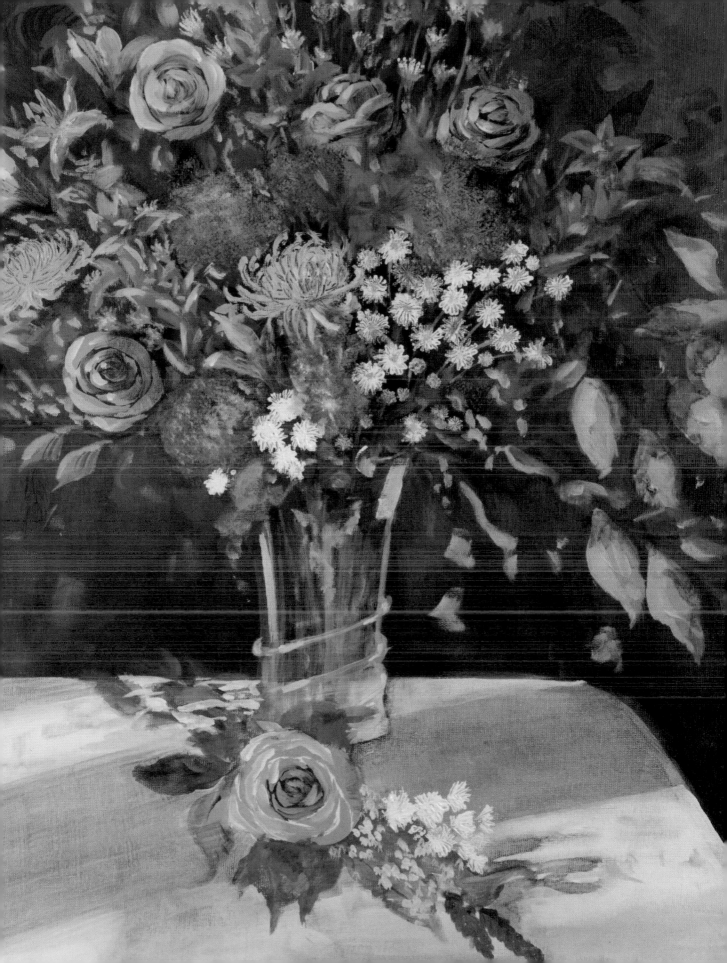

3 Mediterranean plate

This painting sets out to create the illusion of having stumbled upon a tableau from real life. Its success, however, depends on careful composition – with a good deal of time spent arranging the vegetables – and accurate sketching to achieve a harmonious balance of shape, colour, and tone. The bold, curved forms of the vegetables are complemented by a background that not only indicates the direction of the light illuminating the tableau, but is subtly textured with vertical brushmarks that draw the eye downwards.

EQUIPMENT
- Stretched canvas
- 2B pencil
- Brushes: No. 2, No. 8, No. 12, No. 14 flat; fan blender; toothbrush
- Plastic wrap
- Indanthrene blue, cobalt green deep, Naples yellow, titanium white, permanent alizarin crimson, cobalt blue, lemon yellow, pyrrole red light, raw sienna, burnt sienna, permanent sap green, burnt umber, phthalo green

TECHNIQUES
- Texturing with plastic wrap
- Spattering

ACCURATE SKETCHING

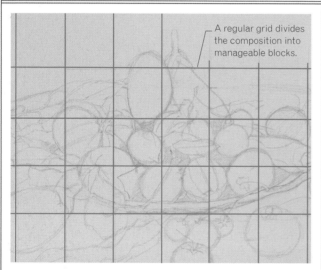

A regular grid divides the composition into manageable blocks.

When aiming for realism in a busy still life, an accurate sketch is essential. Hold a grid between your eye and the subject and draw a matching grid on the canvas. Use the grid lines to help you position the elements accurately on the canvas (see p.24).

Pencil lines should be completely obscured by the paint.

1 Sketch the composition carefully using the 2B pencil; use a grid if you are not confident of your drawing skills. Begin blocking in the background with a coarse mix of indanthrene blue, cobalt green deep, and Naples yellow. Apply the paint boldly and quickly with the large No. 14 brush, or a decorator's brush, for a streaky background that suggests the texture of the wood panelling. Use titanium white with a dash of the background colour to block in the basic light form of the tablecloth.

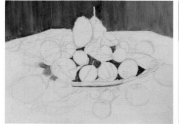
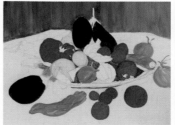
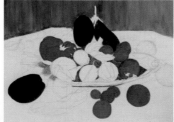
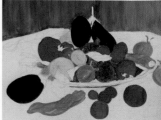

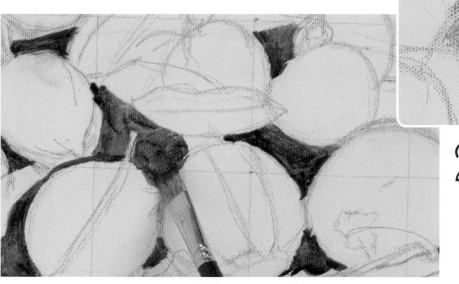

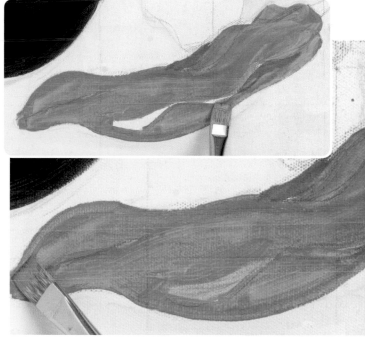

2 Make a purplish-black mixture of indanthrene blue, permanent alizarin crimson, and Naples yellow for the densest shadows between the vegetables. Apply this with the No. 14 brush, lifting excess paint with your fingertip as necessary. These dark outlines will guide the positioning of subsequent colours.

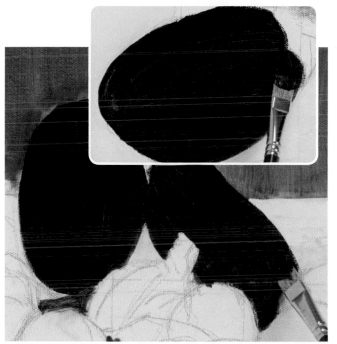

3 Make the rich colour for the aubergines from indanthrene blue and permanent alizarin crimson; block in the aubergines using the No. 14 brush. When the paint is dry, apply a second coat to capture the velvety intensity of colour. Add a little cobalt blue to the mix, and stroke the brush over the surface, guided by the rounded forms of the vegetables.

4 Mix lemon yellow with a little pyrrole red light and block in the orange pepper in the foreground, following its shape with your brushstrokes. Apply paint more thickly to the denser areas so that the colour intensity varies. While the paint is still wet, apply the flashes of green flesh – a mixture of cobalt green deep and lemon yellow.

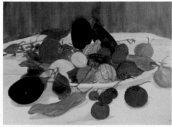
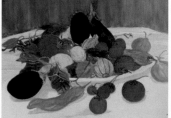
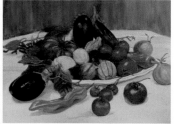

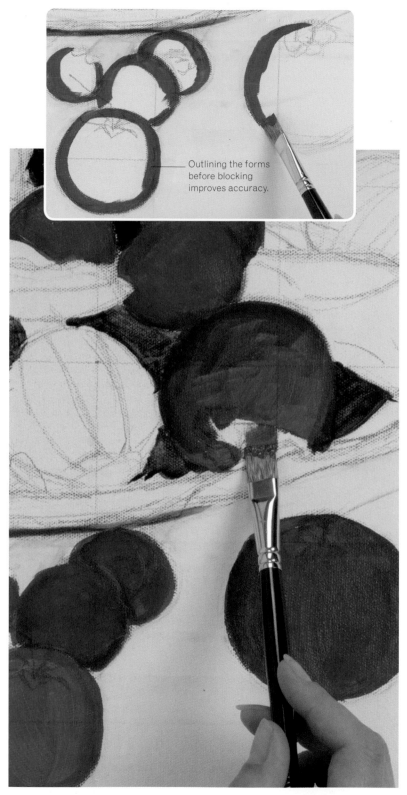

Outlining the forms before blocking improves accuracy.

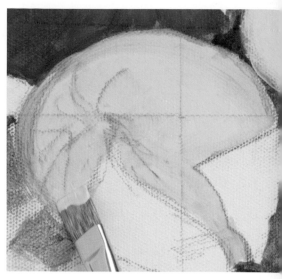

6 Block in the skin of the lemons using the No. 8 brush and lemon yellow mixed with a little water. This sets out their basic shape and colour, ready to be worked over later.

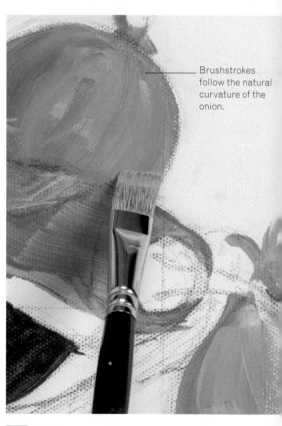

Brushstrokes follow the natural curvature of the onion.

5 Establish the tomatoes, first outlining their forms with pyrrole red light applied with the No. 8 brush. Block in with the same colour, then add some permanent alizarin crimson, and work wet-on-wet to build the darker reds; add lemon yellow for the lighter areas. Use the differing red tones to bring out the sinews of the tomatoes.

7 Use just one colour – a mixture of raw sienna, burnt sienna, and Naples yellow – to set out the basic form of the onions. Apply the paint with the No. 8 brush to the shadowed areas of the onions, and then drag the brush, allowing the paint to become thinner in the lighter areas of the onion.

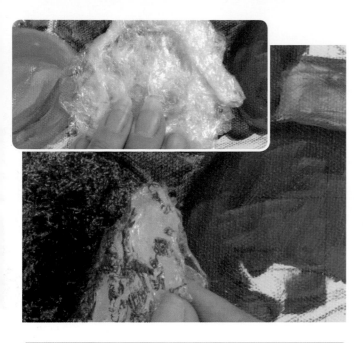

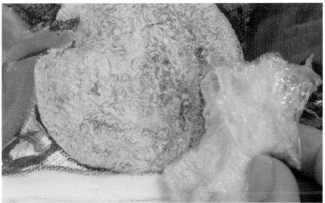

8 Use crumpled plastic wrap to achieve the mottled colour of the gourds. Mix together sap green and cobalt green deep and apply the paint thickly with a brush to the canvas. Tear off a piece of plastic wrap, crumple, and press down on to the painted area. Allow the paint to partially dry for about five minutes before gently lifting the cling film from the surface.

9 Allow the paint to dry, then repeat the plastic wrap process from Step 8 over the dark green gourds, but this time with a paler, yellowish tone mixed from titanium white, raw sienna, and Naples yellow. Note how the light mottling over the dark colour beneath produces an intriguing organic texture.

RELATIVE VALUES

Green leaves and stems play an important role in paintings of vegetables, fruits, and flowers. They snake between the colourful organic forms, helping to tie together the composition. Moreover, greens are "cool" – recessive – relative to warm reds, and "warm" – advancing – compared to bluish hues, so they help to clarify spatial relationships between elements.

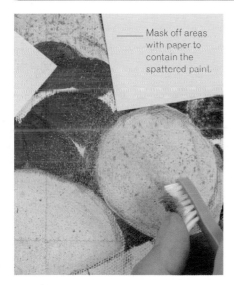

Mask off areas with paper to contain the spattered paint.

10 Give the lemons an irregular, pitted texture by using a toothbrush to flick paint on to their surface. Mix together cobalt blue, lemon yellow, and raw sienna thinned with a little water. Pick up the paint on a dry toothbrush and flick the bristles with your thumb so that the paint sprays on to the lemon.

11 Paint the edge of the plate on which the vegetables sit with the No. 8 brush loaded with titanium white mixed with a fleck of Naples yellow. Add a little cobalt blue to delineate the underside of the lip of the plate, which is in very slight shadow.

12 Use the No. 8 brush to outline the lemon leaves with a mixture of indanthrene blue and cobalt green deep; then block in the leaf areas. The green leaves and stems play an important role in the painting, linking together different areas of the composition.

13 Make a thin mixture of titanium white and indanthrene blue and paint the light shadows of the vegetables on the tablecloth; the recessive blue colour pushes the subjects further forward towards the viewer's eye.

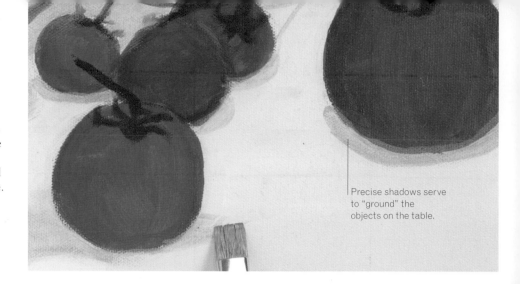

Precise shadows serve to "ground" the objects on the table.

> "Shapes and colours echoed across the composition give a painting balance and poise."

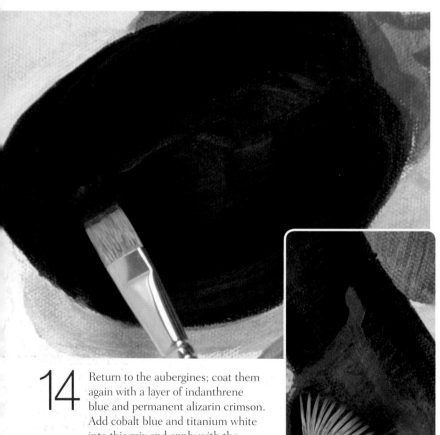

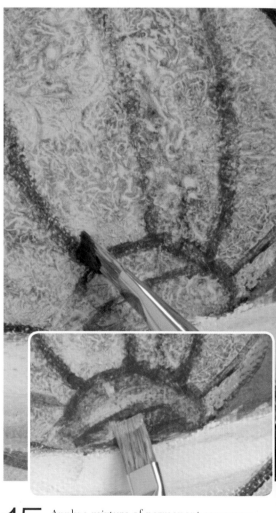

14 Return to the aubergines; coat them again with a layer of indanthrene blue and permanent alizarin crimson. Add cobalt blue and titanium white into this mix and apply with the No. 12 brush. While both layers of paint remain wet, use a fan blender, lightly wetted with water, to blend the highlights convincingly into the body of the aubergine.

15 Apply a mixture of permanent sap green and cobalt green deep with the No. 2 brush, making green lines to help define the rounded form of the gourds. Accent the green lines with a lighter colour – a mixture of titanium white, raw sienna, and Naples yellow. This both adds colour and boosts the contrast of the green lines.

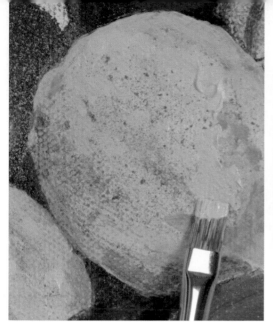

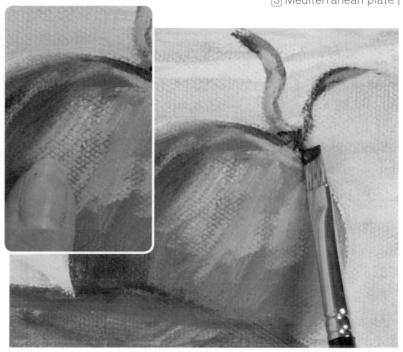

16 Refine the lemons, making their colour less regular, and their shape more contoured and knobbly. Mix Naples yellow and titanium white with varying quantities of the previously mixed greens; rework the outlines of the lemons to add irregularities, and patchily add more acidic yellow and green tones to the skins of the lemons.

17 Revisit the onions to add modelling to their form. Mix burnt umber and indanthrene blue and use it to shade the left side and underside of each onion. Lighten the top of the onions with raw sienna and Naples yellow to complete the illusion of rounded shape. Use your fingertip to blend the colour where necessary.

18 Add more detail and texture to the green leaves and stems throughout the painting using the No. 2 brush. Mix a dark green from indanthrene blue and cobalt green deep, and lighter tones by adding varying amounts of titanium white and cobalt blue. Use the light and dark tones to play against one another to conjure undulating forms from the base leaf colour. Fluid strokes of the brush and low-contrast pairings of darker and slightly lighter greens are good techniques for drawing out the subtleties in the forms of the leaves.

19 Make a coarse mixture of pyrrole red light and lemon yellow, and work over the base colour of the pepper on the left-hand side of the painting. Flashes of unmixed colour add interest to the surface. Add first some more pyrrole red light, and then some phthalo green to the mixture and apply wet on wet, following the sinuous curves of the pepper. Repeat with the pepper on the right, adding some burnt sienna to the mix.

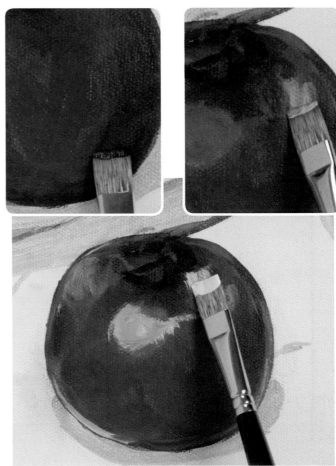

20 Add the dark shadows and lines that help to throw the vegetables into relief. Mix burnt sienna with a little permanent alizarin crimson and use the No. 12 brush to paint shadows between the raised surfaces on the large beefsteak tomato. Add some pyrrole red light to the mixture and apply this paint thickly to the base of the tomato to seat it on the plate.

21 Return to the tomatoes in the foreground. Brush in deep red tones, made from burnt sienna and permanent alizarin crimson, in harmony with their curved surfaces on their shadowed sides. Apply the orange mix from Step 5 to the tops of the tomatoes to indicate warm reflections, then use pure titanium white for the brightest highlights, blending this when wet into the orange mix.

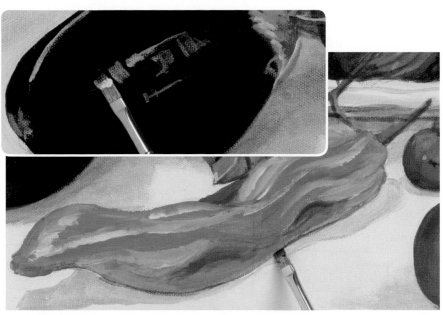

22 Mix cobalt blue and titanium white for the brightest highlights on the aubergines, and apply with a dry brush; blend in with your fingertip. Closely examine the shape and intensity of highlights on the other vegetables, and repeat as above. Add indanthrene blue to the mix, and apply the fine shadows beneath the vegetables to ground them.

Mediterranean plate ▼

This piece shows how bold brushwork and unusual techniques, such as paint spattering, can be used to create stunning representational paintings, despite the fast drying times of acrylic paints.

Life and Portrait

"Aim to provide a glimpse
into the personality and
the life of your subject."

Painting the face

Portraits demand a high level of observation because there is a great temptation to perfect features as you paint, rather than recording the actual jut of a person's chin, or the crooked line of his nose. As you begin to make decisions about a portrait, bear in mind that you are trying to record both physical features and personality. The mood you choose is critical as it is often taken to express temperament. Careful decisions about lighting, colour, and texture are as important as those about line and form.

FACIAL PROPORTIONS

The general guidelines set out below are useful when you are painting a face. But remember that everyone is different, and that the elusive "personality" that you are striving to record often lies within these very differences, so be sure to portray them accurately. As you draw, keep looking back to your subject to check that each feature is correctly positioned in relation to others.

The head is egg-shaped, with the broader end at the crown. The nose marks its central axis. The eyes are positioned halfway up the head and are about one eye-width apart.

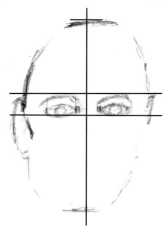

The eyebrow lies just above the eyes, and marks the approximate height of the ears.

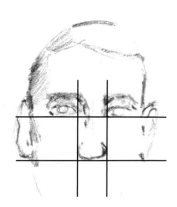

The bottom of the nose aligns with the bottom of the ears. The outer sides of the nostrils lie in line with the inner corners of the eyes.

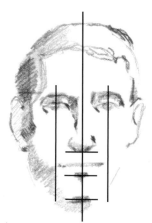

The mouth sits midway between the chin and the nose; its corners align with the centre of the eye.

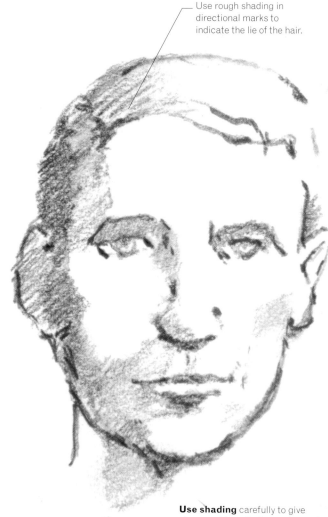

Use rough shading in directional marks to indicate the lie of the hair.

Use shading carefully to give shape and form to the contours of the face. Accentuate some lines in your sketch to show strength and personality. Darken shadows to add highlights and mood.

SKIN TONES

Skin tones vary widely, from very pale, through the mid-tones, to very dark. They can be painted in almost any colour – artists have successfully painted skin in purples, oranges, and greens. The key to painting skin lies in identifying and representing the relationships between tones, rather than colours. Once you have mapped out the planes and features of the face, the addition of highlights and shadows will really bring your portrait to life.

SKIN TONES PALETTE

| Burnt umber | Burnt sienna | Payne's grey | Indanthrene blue | Cobalt blue | Titanium white |
| Mars violet | Alizarin crimson | Pyrrole red light | Raw sienna | Yellow ochre | Naples yellow |

Your palette The colours shown here will allow you to mix an almost limitless range of realistic skin tones. Remember that a person's skin will also reflect the colours of surrounding objects.

PAINTING PERSONALITY

Try to tell a story in your portraits. Think about who you are painting, and how they would like to be seen. Will your picture represent an intimate glimpse of a private moment, or stand as a detached assessment of a public figure? Spend time thinking about how best to display your sitter's personality. This may be represented by the pose they take up, the props they hold, or the chair or background in which they sit. The composition should focus on the sitter, but still flow and hold the viewer's interest. Use colour and light to emphasize the most important features of your portrait.

The artist has used the full range of tones to describe the planes of the woman's face and suggest a blazing hot sun.

The pale, bluish-white background around the face acts as a tonal counterpoint to the face, pushing it forward.

The woman's white teeth are thrown into relief by the shadows of her face, making her smile the painting's focal point.

The warm and cool colours of the bright beadwork are reflected in tones across the subject's face.

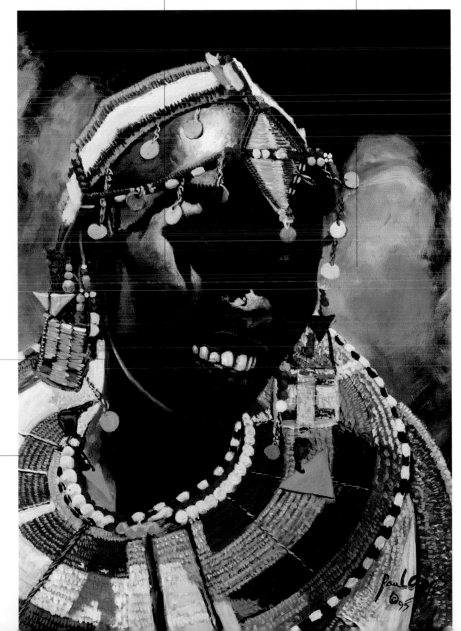

The Chief's Wife The beadwork functions in many ways in this picture. The strong, primary colours act to frame the subject's face, and dazzle us in reflected sunlight. Its elaborate nature also denotes status, and leaves us in no doubt that this is a portrait of an important woman.

Figures and movement

A good understanding of proportion and scale is essential for successful figure drawing. Once you have established the head measurement you can begin to sketch out the rest of the body. Stay objective, and make sure you paint or sketch what is really there, rather than how you think an arm or leg should look. Bear in mind that a characteristic gesture may be as important as a distinctive feature.

BODY PROPORTIONS

The basic unit you use when drawing figures is the model's head, measured from top to chin. To establish this measurement, hold a pencil in front of you, the top level with your model's head, and slide your thumb down until it is level with the model's chin. This is the size at which you will draw or paint your model's head on the support. It is known as the basic head measurement. In the average human, the head fits into the standing figure approximately seven to eight times. When establishing body width, it is helpful to note that the shoulders are roughly "three heads" wide.

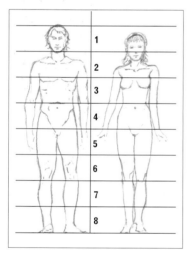

The human body
The female figure differs slightly from the male. Men's hips are narrower than the shoulders, whereas in women they are equally wide. Women generally have a longer pelvis and proportionally shorter legs.

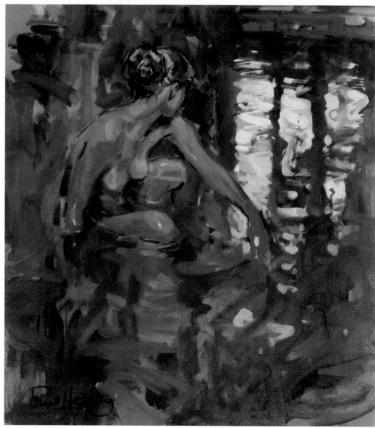

Painting the body Figure painting is always informed by proportion and the underlying structure of bone and muscle. Focus on the shapes and planes, and then build up the figure by working in tones, describing both the light and the structures on which it falls.

PAINTING CHILDREN

The heads of babies and young children are large in proportion to the rest of their bodies, making up nearly a quarter of their full body height. The remaining proportion is split equally between the trunk (shoulders to hips) and the legs. As a child grows, the proportions of the head and legs change until the head is around one-eighth of the body, and the legs account for half of the full body length.

Natural poses Children are often painted from photographs because they are too restless to sit for long. A quick colour sketch (see p.18) will help establish tones and composition.

Look for negative spaces to help define form, such as the triangular shape under this girl's arm.

CAPTURING MOVEMENT

Movement of the human body can be suggested in a painting by pose – the way in which weight is distributed and the shapes and positions of the limbs. Combined with our intrinsic knowledge of anatomy, these cues are often enough to show how and where a person is moving. Other tricks help reinforce the illusion: for example, leaving space for a figure to "move into" suggests direction, as does the use of heavier line or stronger colour on the leading edge of movement. This group of dancers (*below*) explores more techniques.

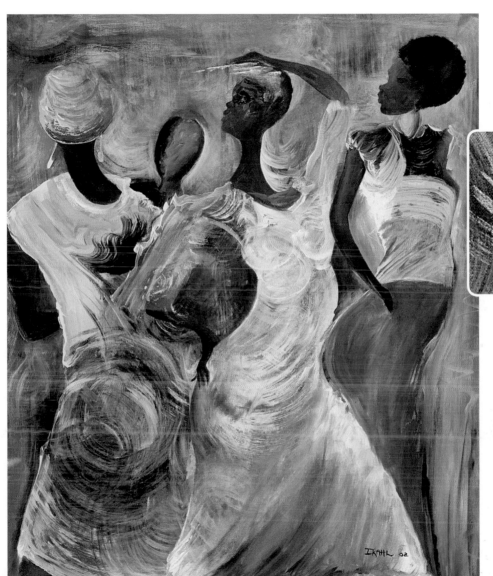

Coloured perceptions
Colour can be used to emphasize the relative positions of the body. A flash of strong red – an advancing colour – brings the dancer's buttock and thigh emphatically forwards in this composition.

Moving lines Echoing lines, repeated as they move through space, give an impression of fast motion. This effect is similar to viewing a moving figure under a stroboscopic light. Here, we can almost see the rotating motion in the dancer's swirling hips. Sweeps of lines in fabric can also give powerful clues about the direction of motion.

Blurring distinctions
Photographs record motion as a blur, because objects move during the exposure. This can be recreated in a painting by blending colours beyond the object to which they belong, in the direction of motion.

Gallery

Fast-drying acrylics are perfect for the immediacy of painting life, and their ability to be overpainted allows fine adjustment of pose and expression.

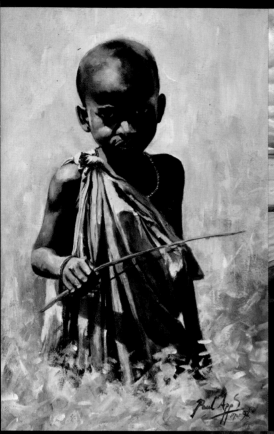

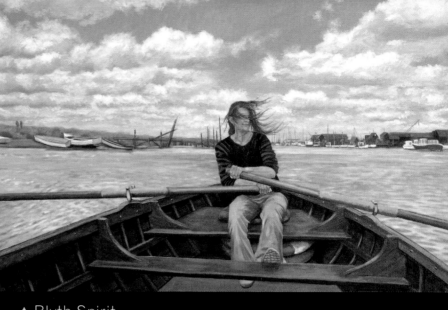

▲ Blyth Spirit

Perspective is the key compositional tool in this picture. The vanishing point lies directly behind the female figure, so that we are drawn in and immediately up to her portrait, as fast as the wind that whips her hair and creates ripples on the water. The sense of movement is intensified by the tension in her arms and legs. *Karen S.J. Keable*

▲ Tribal Boy

The use of a light, plain background pushes the small boy forward and creates the blur of a heat haze. The folds of the mauve fabric are described through tones, and intensified by the surrounding complementary yellow. *Paul Apps*

Late Afternoon, Salcombe ▶

The pose of the older girl creates a triangular central composition in this painting. The loose touches of blue and sparkling highlights across the water suffuse the picture with light. *Dianne E. Flynn*

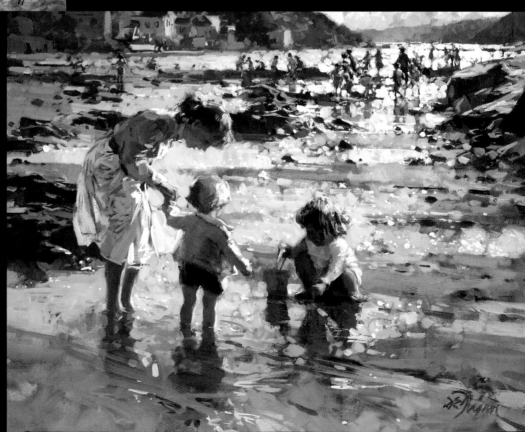

◀ The Lookout

The intensity of tones and colours around the girl draw us into this picture, before her pose leads us across the painting and towards the vanishing point of the river in the background. The artist has blended the buildings to help them recede into the background, while the detail in the foreground is compellingly realistic. *Paul Hedley*

▲ Rear View

This artist has carefully positioned the nude so we are forced to "see" the shape of her leg as a block of colour, like the shapes around it. This more abstract sense of shape is reinforced by the strong lines containing the areas of colour. *Anne Paton*

◀ Awaiting

This painting evokes great sadness – the subjects' faces are averted, as though they are totally overwhelmed by emotion. The stark contrast of black and white seems to echo the passing of some shocking event, and only the table behind the figures keeps them grounded. *John Worthington*

4 Girl reading

In this delicate portrait of a young girl, focus is deliberately directed to the face through careful composition and considered lighting. Rhythmic angles, created by the book, the arms, and the shoulders lead ever upwards; and the use of soft light, reflected upwards from the pages of the book, adds extra illumination to the face. When painting the portrait of a child, it pays to set up a pose in which they are engaged in an enjoyable activity: the pose will be maintained for longer and the result will be a more natural, spontaneous likeness.

EQUIPMENT
- Stretched canvas
- 2B pencil
- Brushes: No. 2, No. 5, No. 8, No. 14 flat
- Alizarin crimson, Payne's grey, pyrrole red light, titanium white, Naples yellow, cobalt blue, yellow ochre, raw sienna, burnt umber

TECHNIQUES
- Glazing
- Blending

1 Sketch the composition with the 2B pencil. With a mixture of alizarin crimson and Payne's grey, begin blocking in the richly coloured sofa with the No. 14 brush. Apply the paint thickly, following the nap of the fabric with your brushstrokes. Work carefully around the sketched figure of the girl.

2 When the first coat is dry, apply a second to intensify the colour of the sofa. Add more Payne's grey and paint the darker areas of the background and the outlines of the cushions. Apply this paint wet on wet, blending the darker tones into the background colour with the No. 14 brush.

BUILDING THE IMAGE

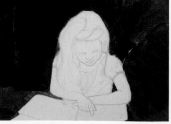

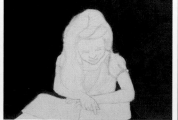

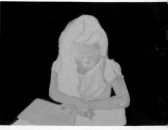

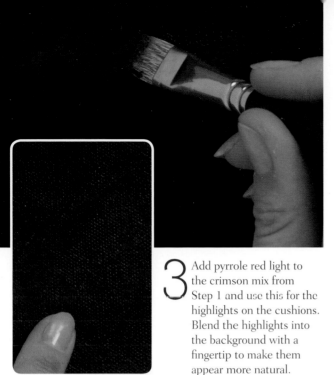

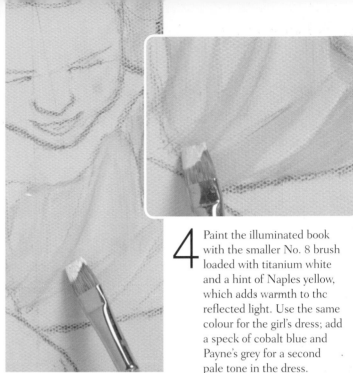

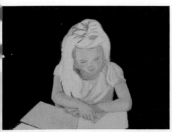

3 Add pyrrole red light to the crimson mix from Step 1 and use this for the highlights on the cushions. Blend the highlights into the background with a fingertip to make them appear more natural.

4 Paint the illuminated book with the smaller No. 8 brush loaded with titanium white and a hint of Naples yellow, which adds warmth to the reflected light. Use the same colour for the girl's dress; add a speck of cobalt blue and Payne's grey for a second pale tone in the dress.

> "A plain, dark background gives a portrait drama and depth."

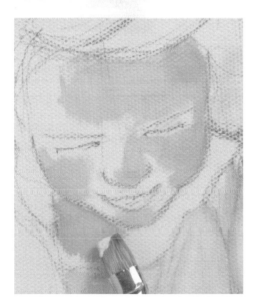

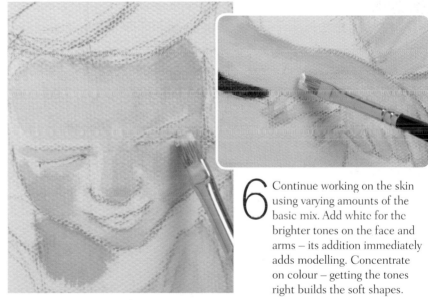

5 Paint the skin tones, which are made up of layered colours mixed from a basic palette of pyrrole red light, Naples yellow, yellow ochre, and, predominantly, titanium white. Start by blocking in the forehead and cheek areas.

6 Continue working on the skin using varying amounts of the basic mix. Add white for the brighter tones on the face and arms – its addition immediately adds modelling. Concentrate on colour – getting the tones right builds the soft shapes.

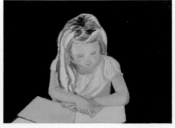

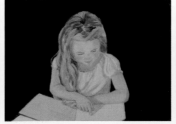

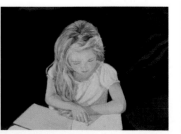

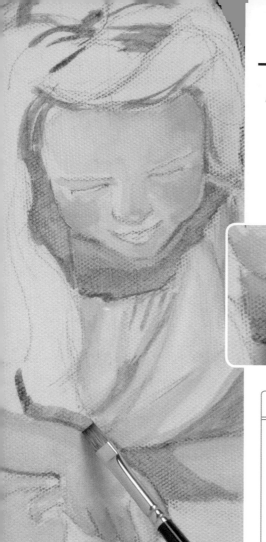

7 Add shadows using a translucent, watery glaze of Payne's grey and cobalt blue applied with the No. 14 brush. Start by outlining the darkest areas, such as the edges of the book and between the girl's fingers; add thinner glaze under the chin, in the folds of the dress, around the head, and in the densest areas of the hair. Blend with a finger to achieve consistent tone.

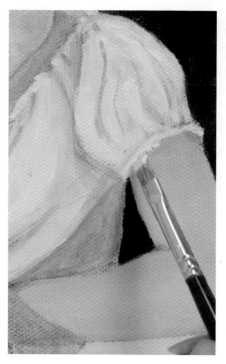

PAINTING CHILDREN

The proportions of a child's body are very different to those of an adult. The head is proportionately larger and rounder, while the eyes are almost adult size. The facial features appear lower down and more compressed on a child's head than on an adult's, and the chin and nose are not very prominent.

8 Use pure titanium white to highlight the ruff on the left shoulder of the dress; this small detail pulls the figure forward, giving dynamism to the girl's pose. Warm up the skin by adding raw sienna and a little more yellow ochre to the basic skin mix: test the colour on a small area before applying, and remember that the skin tones will darken as they dry.

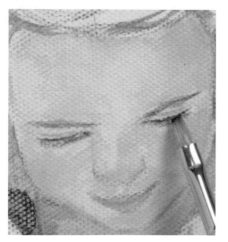

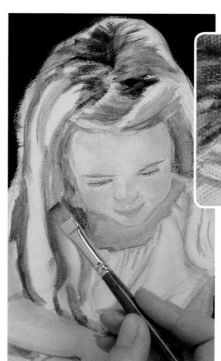

9 Mix raw sienna with a little burnt umber and titanium white for the eyebrows and lashes; add some Payne's grey to the mixture for the slender line of the eyelids. When painting the eyelashes, make very light marks with the No. 8 brush held broad-side on.

10 With the broad No. 8 brush, paint the dark areas of hair with a mix of yellow ochre, raw sienna, Naples yellow, and burnt umber. Work over the blue glaze, using loose strokes. Then, mix a lighter hair colour from raw sienna and yellow ochre only; apply again in loose strokes following the direction in which the hair falls.

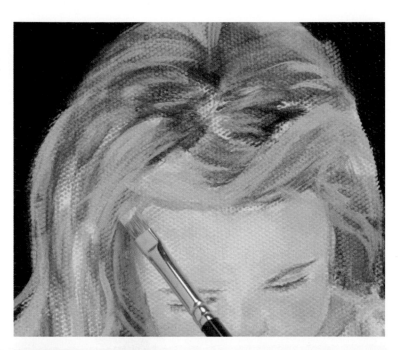

11 With the No. 5 brush, apply a mix of Naples yellow and titanium white to the lighter parts of the hair. Make sweeping marks in a variety of directions to suggest strands of hair. Finally, revisit the skin with a slender No. 2 brush, adding dark tone to delineate the face and arms, so pulling them forward. Darken the eyelids, the edges of the nose, and the crease above the lip. With titanium white and a little Naples yellow, pick out the highlights in the face; a simple mark brings forward the tip of the nose and chin.

Girl reading ▼

Smooth skin tones, high-key lighting, and close attention to facial proportions ensure the girl's youthful appearance. The painting is brought to life by significant details in the fabric of the dress and, especially, in the hair. This is achieved by the layering of many different shades of brown and gold within one limited colour palette.

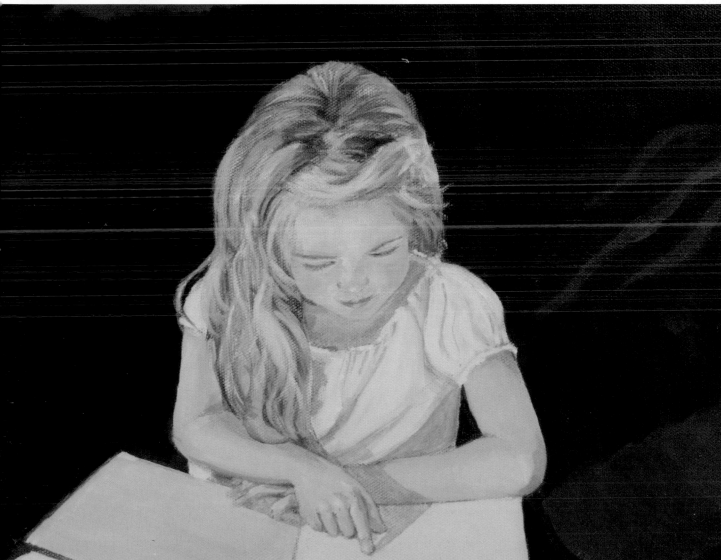

5 Flamenco dancer

Impasto painting literally adds a new dimension to acrylics. The thick, raised, and shaped paint is immediately expressive, the angled planes of its surface catching the light to impart tension and energy, and giving the painting obvious tactile qualities. Here, impasto conveys the explosive movement of a flamenco dancer, whose dynamic posture – outturned leg, and sharp angles of the body and arms – contributes to the spring-loaded composition. Conventional brushwork is a counterpoint, emphasizing the power of the impasto.

EQUIPMENT
- Primed MDF board
- Charcoal
- Acrylic retarder
- Brushes: No. 6, No. 12 flat; decorator's brush
- No. 3 palette knife
- Lemon yellow, pyrrole red light, indanthrene blue, Naples yellow, raw sienna, titanium white, cobalt blue

TECHNIQUES
- Impasto
- Spattering

1 Sketch the figure with charcoal to capture the dancer's energy in line and tone. Mix lemon yellow, pyrrole red light, and indanthrene blue to block in the background with the broad No. 12 brush. Switch to the No. 6 brush for more precise work close to the body.

2 Add Naples yellow and raw sienna to the dark mix from Step 1 and work over the darker skin areas, previously shaded with charcoal, with the No. 6 brush. For the lighter areas of skin, add more Naples yellow and lemon yellow to the mix; work quickly, blending the tones while the paint is wet.

3 Add some pyrrole red light to the mix from Step 2; apply this warmer skin tone to the arms, legs, and chest, blending the tones together while the paint remains wet.

BUILDING THE IMAGE

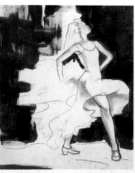

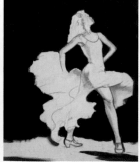

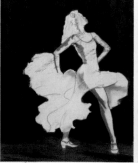

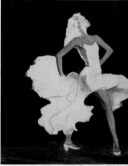

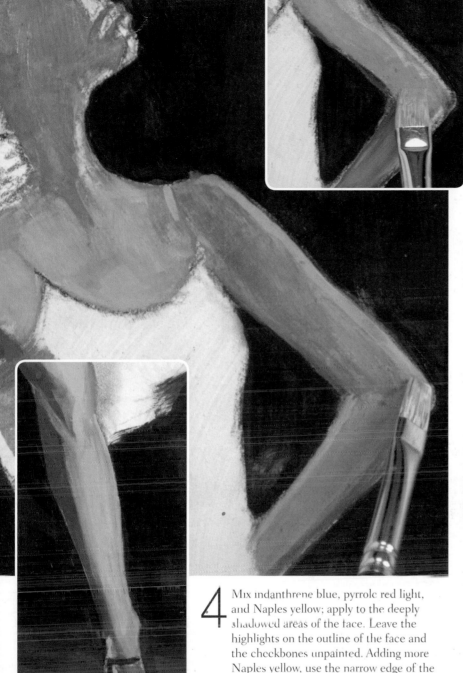

"Impasto has incredibly expressive qualities."

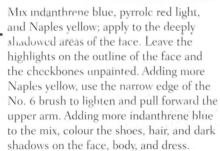

4 Mix indanthrene blue, pyrrole red light, and Naples yellow; apply to the deeply shadowed areas of the face. Leave the highlights on the outline of the face and the cheekbones unpainted. Adding more Naples yellow, use the narrow edge of the No. 6 brush to lighten and pull forward the upper arm. Adding more indanthrene blue to the mix, colour the shoes, hair, and dark shadows on the face, body, and dress.

5 For the vibrant hue of the bodice of the dress, mix pyrrole red light with lemon yellow. Overpaint the darker tones on the left of the body to achieve a gentle, realistic shadow. Fill the remainder of the bodice carefully with the bright colour.

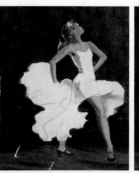
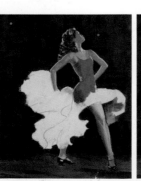
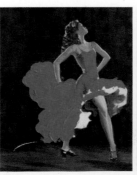

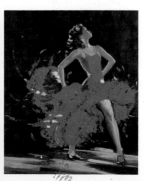

6 Capture the swirling skirt in thick impasto paint. Mix equal parts of pyrrole red light and lemon yellow straight from the tube; add one part of acrylic retarder to three parts paint. Apply with the No. 3 palette knife, following the texture and contours of the moving fabric.

7 Mix raw sienna with the vibrant hue from Step 5 to create a muted red. Apply with the No. 6 brush to the body, wherever the skin catches red light reflected from the dress. Add Naples yellow and titanium white to this mix, and apply the light skin tones, which give the figure relief.

8 Use titanium white for the lighted rim of the face to refine the dancer's expression. With a mix of raw sienna and pyrrole red light, add brown density to the hair. Naples yellow and white make up the hair highlights and also throw out the dancer's shadow from the spotlit floor.

SPATTERING PAINT

An impression of fast movement can be created by spattering or flicking diluted paint on to a surface. Experiment with brushes and paint consistencies – the effect works best when applied subtly.

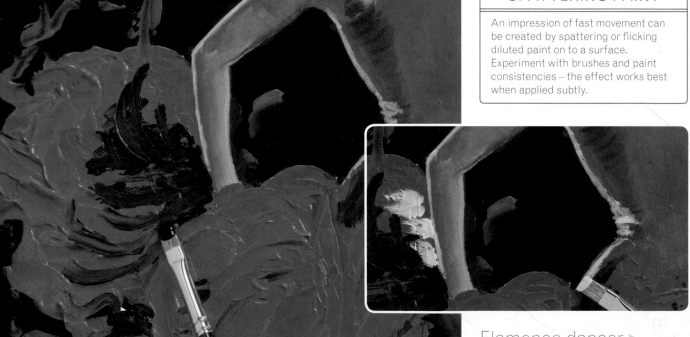

9 With the palette knife, add whorls of red impasto beyond the dress. Delicately work over the wet impasto with a No. 6 brush loaded with indanthrene blue to bring out the shadows in the fabric. Add white highlights to the dress; take the painting into an open, outdoors area, and splatter some dilute cobalt blue using a broad decorator's brush.

Flamenco dancer ▶

Dramatic lighting, impasto, and flicked paint effects conjure up the explosive passion of the flamenco dancer. This is balanced by the more controlled treatment of the upper body.

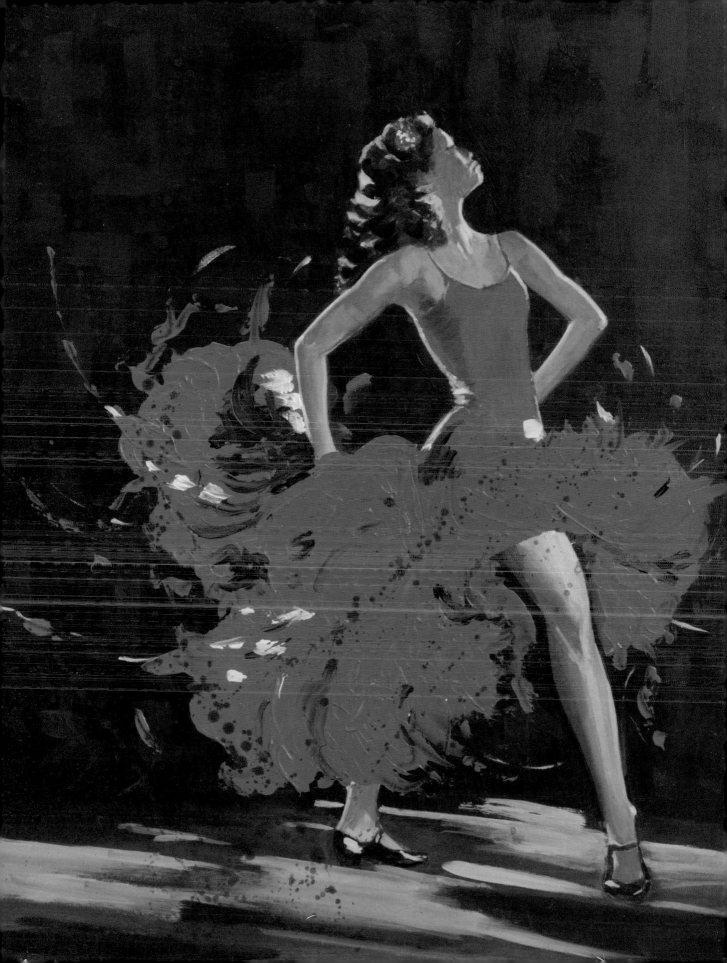

6 Horses and jockeys

This colourful, dynamic composition captures all the excitement of a day at the races; the vibrant colours of the riders' silks seem to push the image forward, out of the canvas. A compressed perspective – the result of using a long telephoto lens to take the reference photograph – helps to place the viewer squarely in the action. The painting becomes progressively more detailed towards the front of the racing group, building a dynamic impression of depth as the riders emerge from the defocused, salt-textured background.

EQUIPMENT
• Stretched canvas
• 2B pencil
• Brushes: 2 cm (¾ in) watercolour brush; No. 6, No. 10 flat; No. 6 round
• Sap green, raw umber, indanthrene blue, cobalt blue, titanium white, quinacridone magenta, pyrrole red light, Naples yellow, Mars violet, Payne's grey, lemon yellow, yellow ochre, raw sienna
• Coarse salt

TECHNIQUES
• Texturing with salt
• Depicting movement

1 Sketch the composition with the 2B pencil, then wet the canvas in the background. Make a wash of sap green and apply to the wet canvas with a 2 cm (¾ in) watercolour brush. Add raw umber and indanthrene blue and extend the darker wash to the edges to make a defocused, contained background.

2 Create a mottled effect in the background just above the riders by sprinkling coarse salt from a salt grinder on to the still-wet paint. The salt grains pull the paint towards them, making raised areas of concentrated colour surrounded by lighter halos. Brush off excess salt when the paint is dry.

BUILDING THE IMAGE

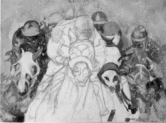

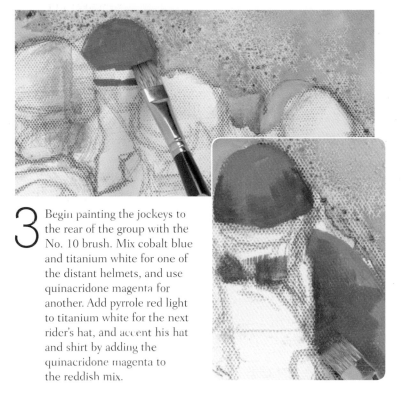

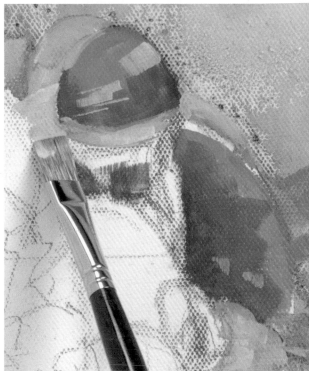

3 Begin painting the jockeys to the rear of the group with the No. 10 brush. Mix cobalt blue and titanium white for one of the distant helmets, and use quinacridone magenta for another. Add pyrrole red light to titanium white for the next rider's hat, and accent his hat and shirt by adding the quinacridone magenta to the reddish mix.

4 Extend the red marks beyond the rider's body – this helps suggest motion. Mix Naples yellow, lemon yellow, and titanium white for the lighter areas of the shirt and helmet; add a dark mark to the rider's face in Payne's grey and raw sienna to show where his visor casts a dense shadow.

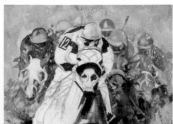

5 Develop the rider to the rear left, using a mix of indanthrene blue, titanium white, and Payne's grey for the top of the helmet, shoulders, and shirt. Colour the sleeves with pyrrole red light, quinacridone magenta, and titanium white, and use the yellow from Step 4 for the helmet.

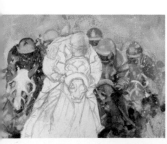

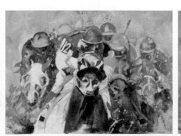

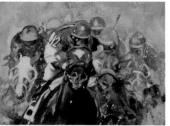

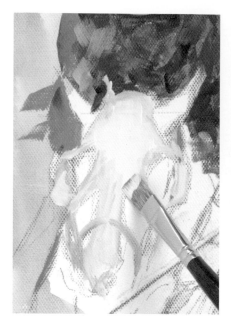

7 Add the dark tones to the horse's nose using raw umber mixed with indanthrene blue. Use the No. 10 flat brush, keeping the marks free. Add yellow ochre to the mix, and use this lighter colour for the flanks of the nose, giving it shape.

6 Paint the blinkers of the horse at the far left with titanium white and Naples yellow. Allow the underlying pencil marks to show through – this adds dynamism to the painting. Next, add the blinkers of the horse to the right using a mix of pyrrole red light and titanium white with a fleck of quinacridone magenta.

SPATTERING

Spattering paint is a useful, though unpredictable, way to suggest motion in a painting. Always experiment with paint consistency and spattering distance before using the technique. To add a measure of predictability to the results, load the brush with paint, and tap the brush on an outstretched finger, so that the spread of droplets is controlled.

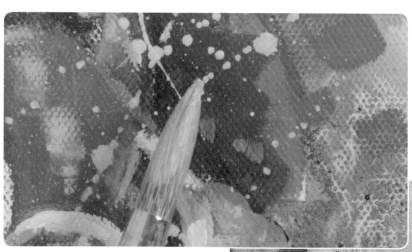

8 Dilute some Naples yellow with water and splash the thinned paint on to the canvas to represent the flying mud around the horses to the left and right. Use the No. 14 round brush, which holds more paint than a flat. Experiment with the consistency of the paint. If it is too thick, it will not flick; if too watery, it will dry transparent.

9 Mix cobalt blue and titanium white and paint the helmet of the rider to the right of the lead jockey. Use the same colour for the horse's noseband and for the highlighted folds in the rider's shirt. Add pyrrole red light and varying amounts of quinacridone magenta to this mix to paint the shimmering tones of the burgundy shirt. Mix indanthrene blue with Payne's grey, and use the No. 10 flat to paint shadows on the rider's shirt and the horse's nose and noseband.

"Cutting off moving figures at the edge of the canvas powerfully suggests action."

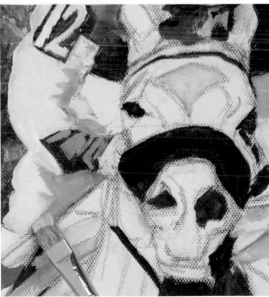

10 Lay down the strong chestnut base colour of the horse with a mixture of yellow ochre, raw sienna, and raw umber. Mix in some Naples yellow, and overpaint when wet to intensify and variegate the colour. Add modelling and highlights to the horse's nose and noseband using titanium white with cobalt blue.

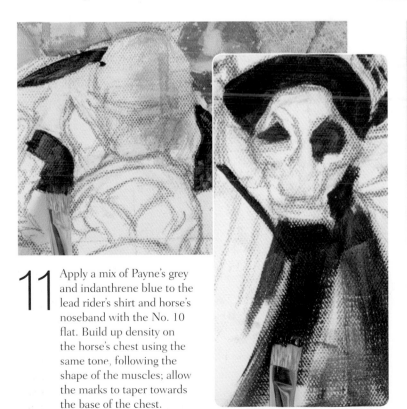

11 Apply a mix of Payne's grey and indanthrene blue to the lead rider's shirt and horse's noseband with the No. 10 flat. Build up density on the horse's chest using the same tone, following the shape of the muscles; allow the marks to taper towards the base of the chest.

12 Mix indanthrene blue, cobalt blue, and titanium white and paint the light tones on the lead rider's silks with the No. 10 flat. Use pure titanium white for the brilliant sleeves and the number on the rider's arm. Follow the rounded shapes of the billowing shirt.

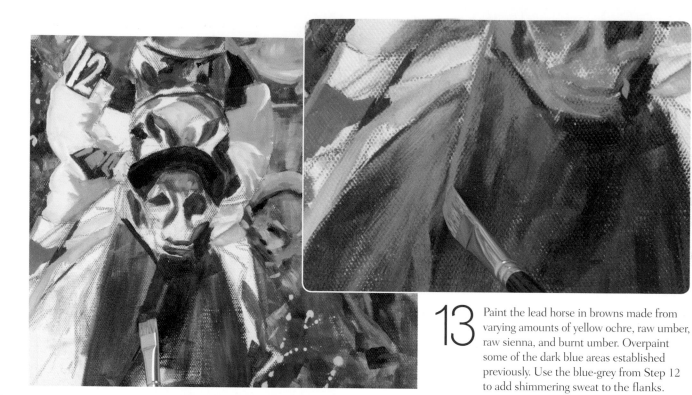

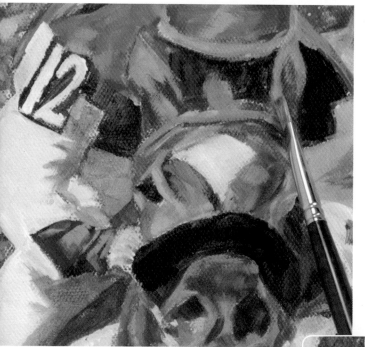

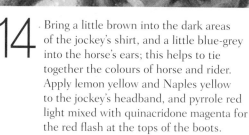

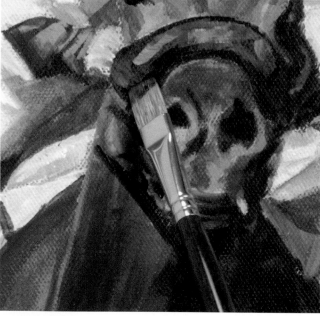

13 Paint the lead horse in browns made from varying amounts of yellow ochre, raw umber, raw sienna, and burnt umber. Overpaint some of the dark blue areas established previously. Use the blue-grey from Step 12 to add shimmering sweat to the flanks.

14 Bring a little brown into the dark areas of the jockey's shirt, and a little blue-grey into the horse's ears; this helps to tie together the colours of horse and rider. Apply lemon yellow and Naples yellow to the jockey's headband, and pyrrole red light mixed with quinacridone magenta for the red flash at the tops of the boots.

15 Add some darker tones made up of indanthrene blue and Payne's grey to the tip of the horse's nose – note how this narrows the nose and gives the head its tapering shape. Apply raw umber, titanium white, and Naples yellow for the lighter details on the horse's nose, and the highlights on the nostrils.

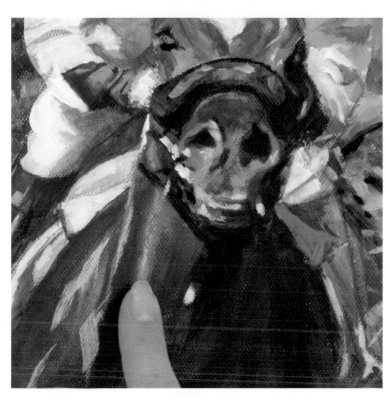

16 Darken the shadow beneath the lead horse's head with some loose vertical strokes of the No. 10 brush carrying the dark mix from Step 15. Finish with a few flashes of titanium white and a little cobalt blue; add these to the boots, the lead jockey's silks, the horse's nose and flanks. Blend these marks back with a fingertip. Add the final flourish – a jockey's whip held at a dynamic angle – using a mix of raw sienna, burnt umber, and Naples yellow.

Horses and jockeys ▼

Nothing is static in this exciting race scene. The whole group leans to one side as it negotiates a corner, flecks of paint indicate flying mud and sweat, and colours fly like streamers from the moving figures. The focus of the painting – enforced by the composition and the compression of perspective – is resolutely forward, towards the finishing line.

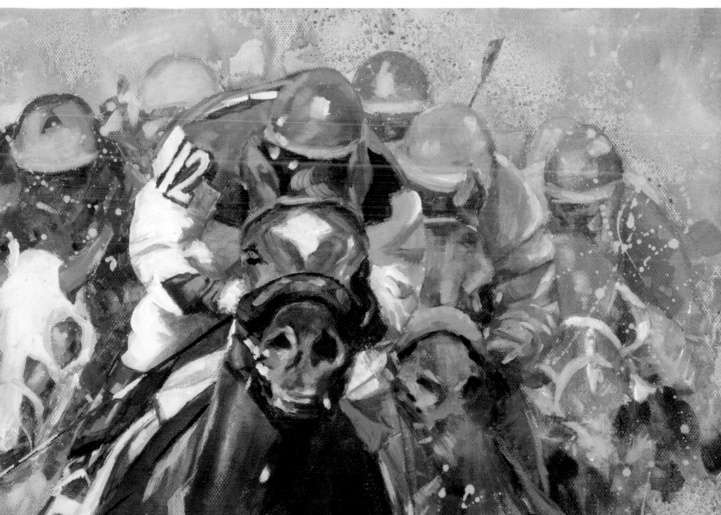

Landscape

"Work with the light —
bring it into your painting
to impart life and vitality."

Realistic perspective

When you add perspective to your paintings, you are essentially trying to reproduce the way that the human eye sees things over distance. Successfully applied, perspective gives paintings the impression of depth and therefore realism. There are a number of ways of creating the illusion of depth: linear perspective, the relative scale of objects, and the colours and textures chosen to represent the scene.

LINEAR PERSPECTIVE

Lines that run in parallel – such as the edges of roads, or rooftops – seem to the eye to run towards one another, finally converging at a point on the horizon (*see diagram below*). Artists use this phenomenon to represent perspective in drawings and paintings. The vanishing point, which is the point at which the lines meet, is always on the horizon – and the horizon is always at eye level. This allows the painter to position the viewer at a certain level or distance from the painting's subject.

Vanishing point

The horizon line is always at eye level, however high or low your position. Test this by looking out of a downstairs and upstairs window.

Using perspective In this beach scene the artist has used several devices to give the painting perspective. The buildings in the foreground are larger than those in the distance, following the rule of scale. The vanishing point lies at the end of the path, on the horizon, following the rule of linear perspective. Notice that the lines of the path move upwards towards the horizon, while the rooftops slope downwards towards it. This reflects the artist's (and viewer's) position with regard to the scene – the horizon is at our eye level, positioning us at standing level on the path.

THE POWER OF GEOMETRY

Geometric forms feature as important compositional elements in many paintings. Their intrinsic harmony and balance helps to stabilize a composition and provide an entry point for the viewer, leading us into and through the painting – from foreground to background. In this way they can usefully add to a painting's perspective. The three most popular compositional forms are triangular, circular or oval, and rectangular arrangements.

This triangular composition follows the lines that define linear perspective. This leads the eye strongly towards the horizon through the centre of the picture.

An oval is used here as a framing device to pull the eye towards the distant hills, and to establish a profound difference of scale between objects in the foreground and background.

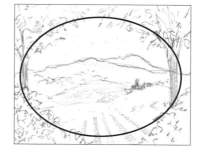

Diminishing rectangular frames defined by the strong verticals of the buildings on the street lead the eye towards the horizon.

ENHANCED PERSPECTIVE

The rule of linear perspective can be supported by other more subjective techniques to boost the illusion of depth. When painting landscapes, try adding progressively more blue to objects with increasing distance; this mimics the natural filters present in the atmosphere. Lessen the intensity of colours with distance, and boost both tonal contrasts and visible detail, in foreground objects. Another technique is to overlap forms; this gives very clear positional and depth cues.

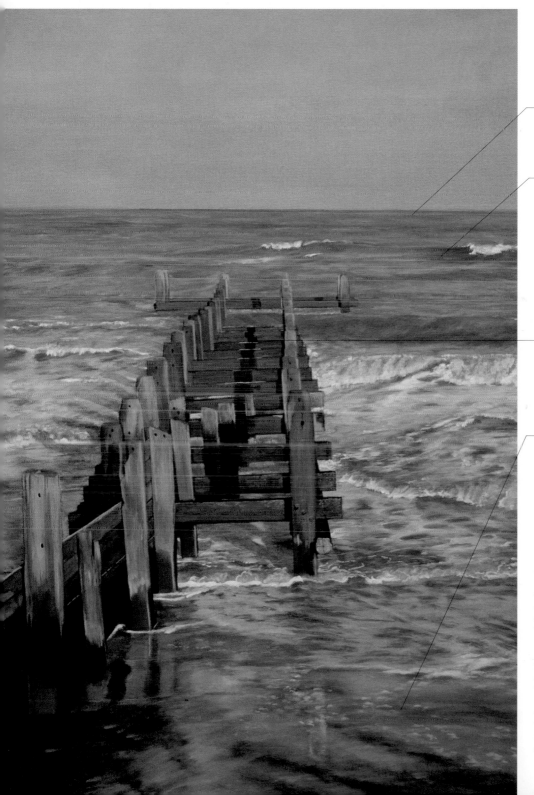

Colours cool and tones lighten with distance.

The edge of the waves becomes less crisp with distance from the viewer.

The line of shadow down the centre of the groynes narrows at the same rate as the width of the wooden structure.

Detailing is more prominent in the foreground; this reflects the simple observation that we see more detail in objects that are closer to us.

A view to the sea This painting uses a range of techniques to convey depth. The diminishing sizes of the wooden groynes give an immediate sense of scale, and the composition utilizes very obvious linear perspective. But even if you block the groynes from view with your hand, several elements still act to give us a sense of perspective. These are the enhanced details and brighter colours in the foreground, the move from defined brushstrokes to a more blended sea in the distance, and the gradual cooling of colour with distance.

Water and sky

Water and sky are elusive, ever-changing subjects; they are affected dramatically by the daily weather, the seasons, and the quality of light at different times of day. They both have a reflective, luminous quality, which creates new challenges for the artist. The colours and tones of the landscape are reflected in the water, while those of the sky are echoed subtly in the rest of the scene.

PAINTING THE WEATHER

When painting aspects of the weather, it pays to practice with sketches of clouds and skies. Explore techniques for capturing visible forms – heavy rain clouds can be built by working wet-on-wet to build density and contour – as well as the other sensory effects of weather. The essence of cold, for example, can be suggested through spiky forms.

Stormy weather Thick, expressive paint effects, such as impasto, can help capture the energy of a stormy sky. Movement and tension – illustrated by the figure struggling with ropes to control a canopy – combine here with a dramatic low viewpoint to emphasize the raw power of the wind.

Summery skies Warmer skies tend to be a still, hazy blue, which calls for more blended, softer lines and glazes. The varying shades of cobalt blue are a good base colour for summer skies; adding glazes of Naples yellow and titanium white gives warmth, while Mars violet glazes indicate distant haze.

SKY AS SUBJECT

The sky can provide the background for your painting or it can become its subject. If the sky over your landscape is very dramatic, you may wish to paint the land in more muted, even tones, while using perspective, contrast, colour, or texture to focus attention on the sky. Don't forget that the rules of linear perspective (*see p.76*) also apply to skies and clouds, and that as they recede towards the horizon, their colours become more muted and their shapes less distinct.

The sky is almost uniform in colour.

Sky as background Blending, and deliberately restricted tonal contrast, keeps the sky muted in this composition.

The looming perspective of these clouds helps to make them the focal point.

Powerful sky This dramatic sky has been painted in an eye-catching, high-contrast style. Restricted tones in the sea prevent the foreground from dominating the scene.

THE COLOUR OF WATER

Water is both transparent and reflective. We can see through it to a fish swimming in a pond, or see only our gaze reflected in its perfect stillness. For this reason there can be no set rules for painting water, which could be any colour – from deep blue to blazing red, depending on the surroundings. On grey days the lack of light makes water seem flat-toned, calling for more muted, low-contrast colours. Brighter days call for highlights and bright, rich colours, with reflected shapes and shadows.

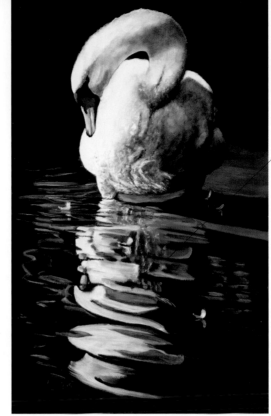

By using high contrast colours and tones the artist is able to portray both the intense daylight and the cool, hidden depths of the water.

Movement and colour Loose, fluid strokes of lights and darks can be used to portray the blurring motion of the water, as ripples distort a reflection.

Water and light The background and the water in this painting appear almost black, but we still see this scene as a sunny day. This is because the intense highlights on the swan and their vivid reflections in the water indicate a strong, low sun.

THE TEXTURE OF WATER

Water is an elusive subject because it is almost constantly on the move – whether this is the slightest ripple or a crashing wave. Choose your brushmarks carefully to convey an impression of movement and fluidity, keeping detail confined to the foreground. Try different techniques to suit the mood of your painting: wet-in-wet washes overlaid with a few reflective brushstrokes can be used to create a scene of still, tranquil water; while impasto and textured paint suggest choppy, rough water. Overglazing can be added to suggest depth and colour, while sponging and spattering are effective for depicting the fine spray of crashing waves.

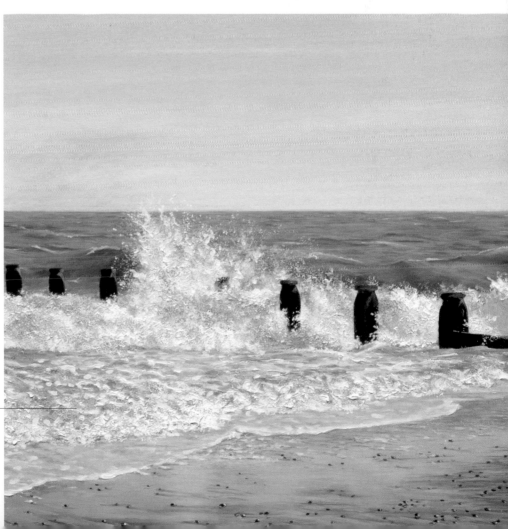

The detail visible in the frothy wash of waves breaking on the beach owes as much to texture as to colour.

Stormy sea The movement of the waves is the focal point of this picture. Thick impasto paint and visible brushmarks create a texture that reflects the force of the water's movement.

The vibrant colours and luminous quality of acrylics make them the perfect medium for creating atmospheric and dramatic landscapes.

▲ Dawn Drama

The strong vertical shapes of the wooden groynes play against the horizontal shimmer of the water and horizon. *Karen S.J. Keable*

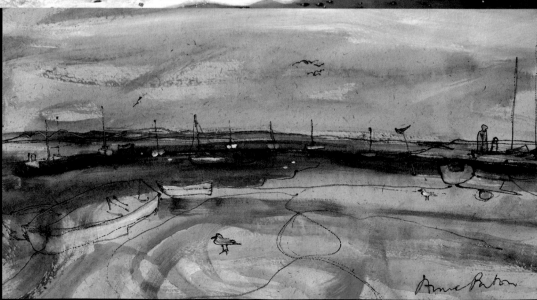

Evening Light ▶

Fluid washes and swirls of ink suggest movement and reflections in this landscape, instantly capturing the essence of the scene. *Anne Paton*

◀ Maison Perdu, Corfu

The bold blocks of colour that make up this landscape give it a strong contemporary feel. The colour red has been used to pull us into the painting through the building's roof, drawing the eye along the path up to the tall cypresses. *Terence Clarke*

▼ Into the Forest

This low-contrast, tonal study of a landscape has an ethereal atmosphere. Translucent glazes have been overlaid to suggest a hazy half-light. *Colin Slee*

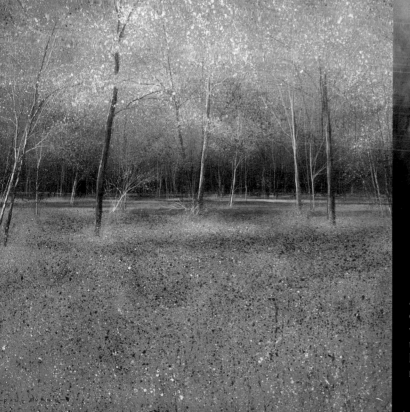

◀ Springtime

A spattering technique has been used here to capture the dappled light and bluebell floor of a woodland scene. By including the detail of the tree trunks and the swathe of dark background, the artist has given a very contemporary, loose painting some representational form. *Paul Evans*

7 Seascape

The sea has always been a compelling subject for painters, perhaps because it can display such a range of moods. This painting shows how to achieve realistic richness of colour in the water by building layers of tone, from the darkest browns and blues, to the lightest mauves and whites. It also addresses how to produce the illusion of depth in what can be a flat and featureless surface. The long, thin shape of the canvas, combined with strong one-point perspective give the painting plenty of "headroom" so that you can almost taste the sea air.

EQUIPMENT

- Stretched tall, thin canvas
- 2B pencil
- Flexible modelling paste
- Brushes: 2 cm (1 in) decorator's brush; No. 8, No. 14 flat; No. 2 round
- Sea sponge
- Cobalt blue, titanium white, raw umber, Naples yellow, yellow ochre, Mars violet, Payne's grey, burnt umber, lemon yellow

TECHNIQUES

- Modelling
- Sponging

1 Sketch the composition on the canvas with the 2B pencil. Begin building texture on the areas where the waves break in the mid-ground of the painting using flexible modelling paste applied with the No. 5 palette knife. Use the knife to stipple, drag, and smooth the paste to represent the foaming water.

2 Allow the modelling paste to dry overnight. Block in the base tones of the sky, and of the shingle foreground with the 2 cm (1 in) decorator's brush. For the sky, use a mix of cobalt blue and titanium white; add more white as you descend towards the horizon, graduating the sky. For the shingle, use raw umber.

BUILDING THE IMAGE

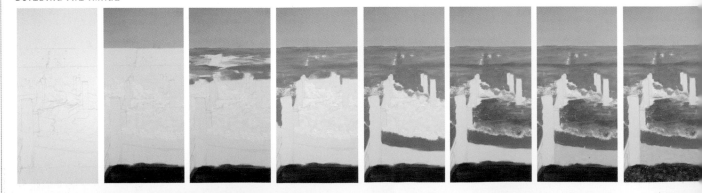

3 Mix cobalt blue, titanium white, Naples yellow, and yellow ochre and block in the areas of sea in the mid-distance with the No. 14 flat. Combine cobalt blue, titanium white, and Mars violet, and work this bluish tone into the still-wet brown beneath.

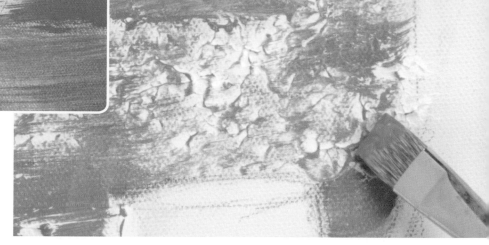

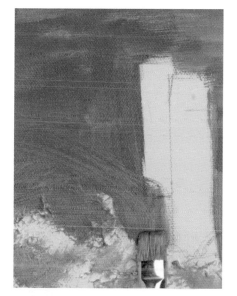

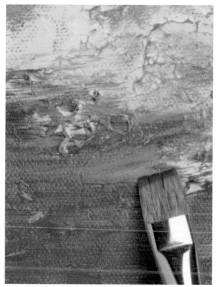

4 Block in the area of wet sand in the foreground using the brown colour mixed in Step 3. Use the brown to boost areas of the sea that do not catch reflections from the sky, such as the lee of the wave.

5 Add a little Mars violet to the brown mix, giving it a subtle warm glow. Apply this paint with the No. 14 brush over the modelling paste to the turbulent water between the groynes.

6 Mix Naples yellow, titanium white, and yellow ochre. Block in the dry sand in front of the shingle. Add more titanium white and work over the yellow, leaving your brushstrokes visible to texture the sand.

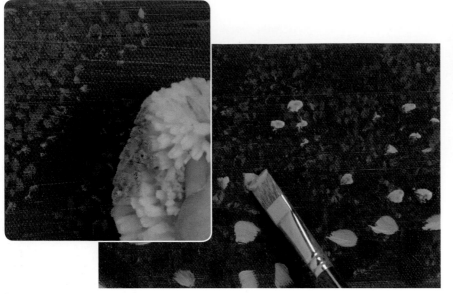

8 Repeat the processes from Step 7 with a mixture of cobalt blue, titanium white, Naples yellow, and yellow ochre. Introduce flashes of both the blue and the yellow colour into the area of dry sand in the foreground to build textural interest.

7 Make an irregular pattern of dots of different size and colour to build the foreground shingle area. Start by dabbing a mix of cobalt blue, titanium white, and Mars violet over the area with a sea sponge. Darken this mix with some Payne's grey, and apply again with the sponge, then add some blobs of this colour for the larger pebbles in the fore- and mid-ground.

CHEATING IN DETAIL

Apparent detail in pebbles, brickwork, or foliage can be conjured up by painting blobs of several colours in sizes that diminish with distance from the viewer. The addition of outlines, or sparse details, in the foreground, creates a busy impression over the whole area, without the need for intensive work.

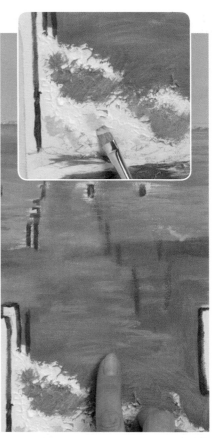

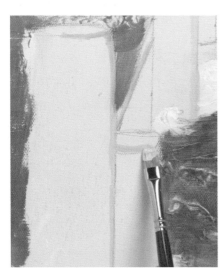

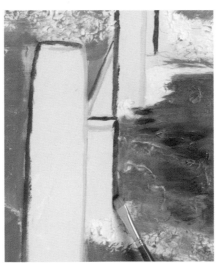

9 Switch to the No. 8 flat brush and paint the highlights on the sunlit edges of the groynes with a mixture of Naples yellow and titanium white. Keep the brushstrokes loose and organic so that the groynes appear old and weathered, but still retain their overall geometric form.

10 Establish the dark outlines of the groynes where their edges are in shadow. Use a mixture of cobalt blue, Naples yellow, yellow ochre, and Payne's grey. Add some streaks of this dark colour to the foamy water to indicate the shadows cast by the groynes on the sea.

11 Mix a pink hue from Mars violet, cobalt blue, and titanium white, and use this colour across the canvas. Apply with the No. 8 brush to the areas of foaming sea, to the shingle area in the foreground, and into the brown-blue sea between the groynes. Blend with a fingertip to create a rippling sea surface.

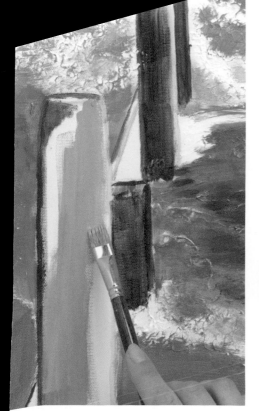

"The sea is never a uniform colour, but a mixture of surprisingly bright hues."

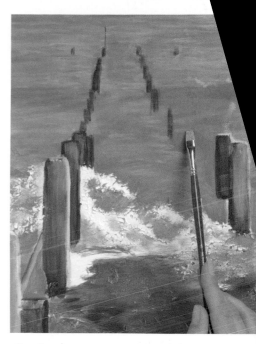

12 Block in the groynes, using a basic mixture of burnt umber and Mars violet, modified with Naples yellow for the lighter areas, and more burnt umber for the darker parts. Use the No. 14 flat brush to blend the tones together while wet.

13 Use the range of brown tones mixed in Step 12 to build more texture in the shingle. Use a sponge to apply the paint in the background, and a brush to make irregular marks in the foreground.

14 Neaten and straighten the horizon line using a combination of the colours mixed in Step 3. Use the same hues to refine the surface of the sea, using the two colours to shape the waveforms. Allow the paint to dry, then add further groynes leading out to sea, to boost the painting's strong one-point perspective.

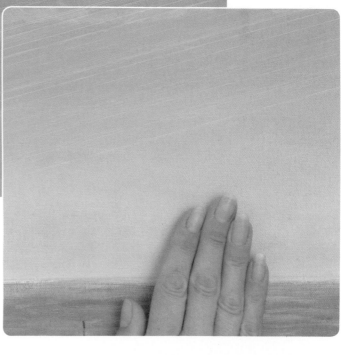

15 Return to the sky area. Mix titanium white with a little Naples yellow and apply the paint loosely with the No. 14 brush in the blue area just above the horizon line. Wet your hand with water and vigorously work the white paint into the underlying blue to achieve a hazy glow. Allow to dry and repeat the process to build the haze. Add wisps of cloud in the same colour and use a wetted finger to blend their edges back into the sky.

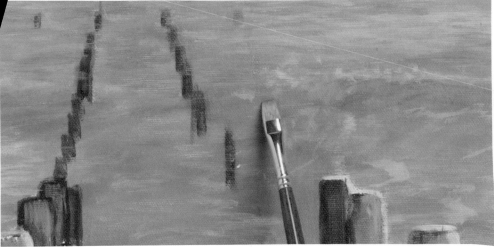

16 Introduce some bright highlights into the sea. Mix yellow ochre and lemon yellow and use the No. 8 flat to pick out the spume on the crest of the oncoming wave. Add swirls of this lighter colour on to the surface to represent patches of foam floating on the water; this helps to suggest the choppy texture of the sea surface.

17 Boost the presence of the groynes, overpainting them with a wash of Payne's grey applied with the No. 8 brush. Allow the paint to spill over the edges of their forms – the result is a suggestion of shadow in the surrounding water.

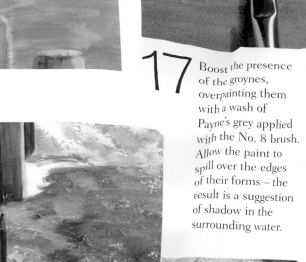

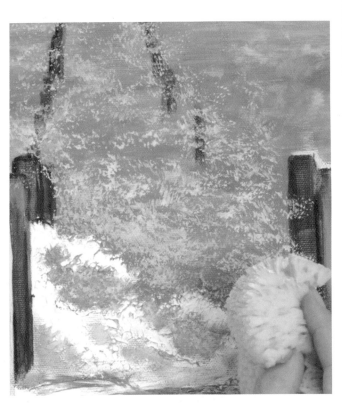

18 Add the sea spray to the foreground. First, lay down the shadows of the spray; mix a light blue hue from titanium white, cobalt blue, Mars violet, and Naples yellow and sponge over the sea area between the groynes. Sponge the white spray on top, using the same mix, but omitting the cobalt blue.

19 Mix titanium white, Naples yellow, and yellow ochre. Paint the yellow spume over the wet foreground, where the surf has churned up the sand. Make a cooler mix of titanium white, Mars violet, and a little Naples yellow to paint the foam at the top of the beach, following the texture of the modelling paste with your brushstrokes.

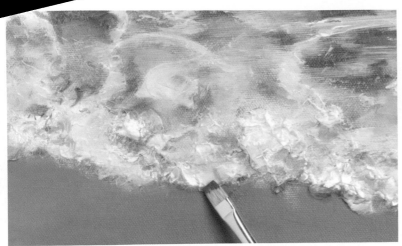

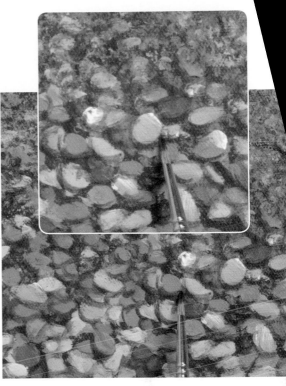

20 Make a watery mixture of Payne's grey and cobalt blue and add swirls of this translucent colour into the foam. Use the same paint to edge the boundary between the foam and the wet sand. The darker rim succeeds in lifting the foam up from the plane of the sand, so giving it movement.

"When painting water, choose a wide brush and keep your marks loose and fluid."

21 Return to the pebbles with the colour mixed in Step 20. Using the fine No. 2 round brush, encircle the areas of colour painted previously to give them defined form. Make sure the pebble size decreases with distance. This is a quick way of creating apparent detail and complexity in a stony surface.

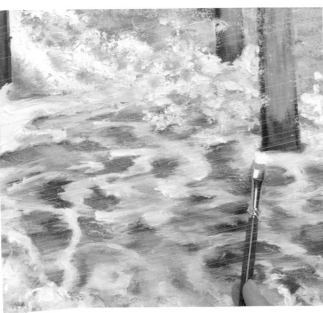

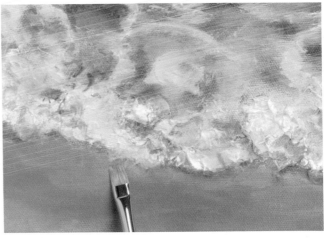

22 Add a hint of Naples yellow to titanium white and reinforce the highlights on the breaking waves over the wet sand. This contributes to the impression of rushing, eddying water. Use the same colour to sponge again over the breaking waves; extend the sponging over the horizon line to unite the background with the foreground. Blur the sponged marks with a fingertip.

23 Mix yellow ochre with Naples yellow. Use the No. 14 flat brush to introduce some light areas into the wet sand. These represent patches of sand that are drying out. Blend the light yellow into the sand with a fingertip. Combine cobalt blue with titanium white and paint the sheen of water brought on to the wet sand by the incoming waves.

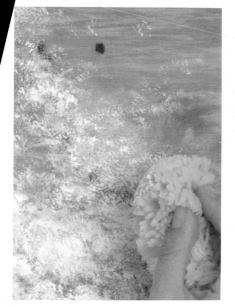

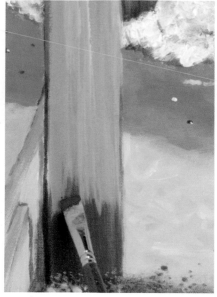

24 Finish the foaming water by adding further layers of sponging with Naples yellow, titanium white, and Mars violet for warmth. Avoid sponging too much; you risk overwhelming the background and so spoiling the impression of spray.

25 Use burnt umber mixed with Mars violet and Naples yellow to reinforce the forms of the groynes. Cover up splashes of the foam that have strayed over the edges – the foam should be predominantly behind the posts.

26 Mix titanium white, burnt umber, and Naples yellow and lightly draw the No. 14 brush down the length of the groynes. Keep the paint loading light so the layers below show through irregularly, suggesting the grain of the wood.

HORIZONS

When painting a seascape from ground level viewpoint, the shoreline and the horizon will divide the canvas into horizontal strips. Such a composition almost always benefits from vertical interest – try figures or groynes in the foreground. The horizon should not be placed mid-way up the canvas – asymmetric compositions are generally more harmonious. As ever, though, rules are made to be broken. A symmetric composition may be more arresting.

27 Examine the shadows cast by the groynes on to the water. Make a watery mix of cobalt blue and Payne's grey and paint the transparent shadows over the water surface. Make sure to keep the angles of all the shadows consistent.

28

Use the No. 2 round brush to add knots to the wood of the groynes. First paint a circle in Payne's grey and cobalt blue, then rim the hole on the highlighted side using a mix of Naples yellow and titanium white to give an illusion of depth.

Seascape ▶

Careful control of tone and colour in the water, with warmer browns in the foreground and the cooler blues at distance, creates a balanced sense of depth. This is accentuated by the apparent detail in the shingle foreground and the action of the breaking waves to give a measured but powerful composition.

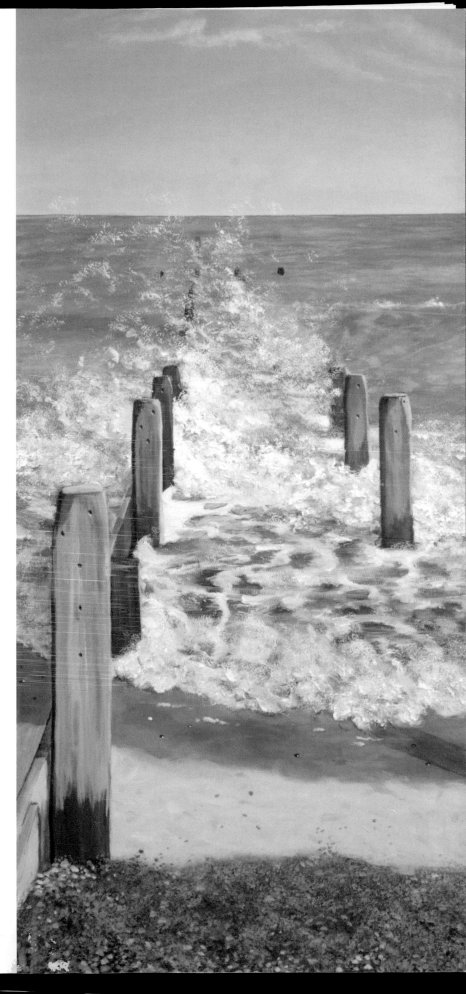

"Multiple blended layers of colour give clouds tangible form."

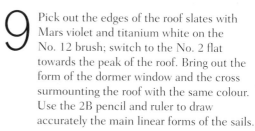

7 Apply titanium white mixed with a little Mars violet for light tones in the clouds. Blend with a wetted finger. Reapply the mauve colour from Step 6 and blend again.

8 Add another layer of titanium white and Naples yellow to the clouds; with each layer, blend less, drawing more distinct forms from the clouds.

9 Pick out the edges of the roof slates with Mars violet and titanium white on the No. 12 brush; switch to the No. 2 flat towards the peak of the roof. Bring out the form of the dormer window and the cross surmounting the roof with the same colour. Use the 2B pencil and ruler to draw accurately the main linear forms of the sails.

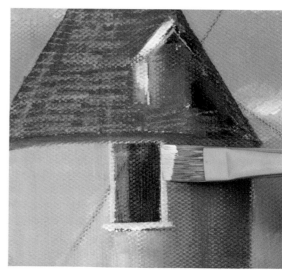

10 Dry brush the main body of the windmill from left to right to enhance its curvature. Paint the slope of the steps to the left hand side, and then highlight the steps and the window frames with the No. 2 brush loaded with Mars violet, titanium white, and Naples yellow.

11 Work over the drawn skeleton of the windmill's sails with the No. 12 brush. Mix cobalt blue, Mars violet, and raw sienna, and apply fine lines of this dark colour to the main members of the sails. Make pencil traces to delineate the smaller struts of the sails; check their proportions and positions carefully before painting with the same colour. Mix titanium white and Naples yellow and highlight the sunlit edges of the struts.

Windmill and vineyard ▼

The combined effect – or optical mixing – of many small dabs of greens, yellows, and browns produces a lively impression of vegetation in the foreground of this painting. This near-pointillist style of working creates flickering colours that could not be achieved by mixing a single shade of green. The clouds are similarly built up quickly, using layers of colour applied in loose strokes.

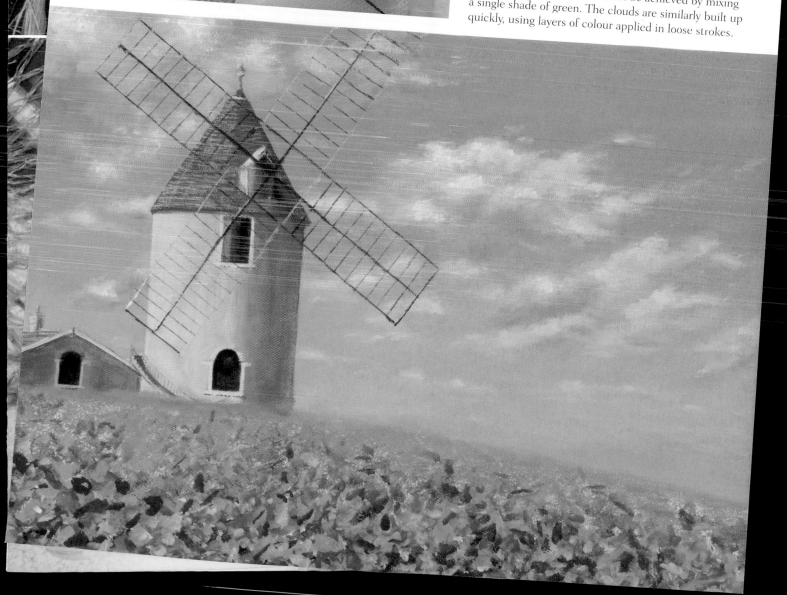

Gallery

Acrylics can be used in conjunction with a wide range of media and techniques to create exciting contemporary art.

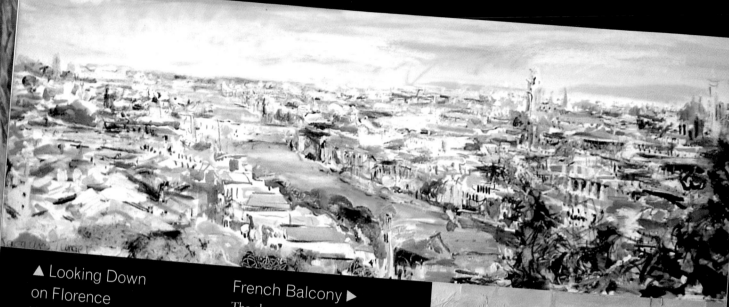

▲ Looking Down on Florence

This lively scene gets much of its vivacity from the wide variety of media employed, including iridescent, fluorescent, and standard acrylics, collage, felt tip, and wax crayons. The bush in the foreground helps frame the scene and provides perspective. *Jacquie Turner*

French Balcony ▶

The almost-tangible texture of this painting derives from its multi-media layers. The artist painted the scene in acrylics, then applied coloured and torn papers for texture and depth, before overpainting it all in acrylic to unify the painting. The texture helps move the cool blue of the balcony into the foreground. *Sylvia Paul*

◀ Harbour Lights, Reflections

This was painted on location, and its simplicity adds much to its effect. The artist laid down a tonal wash as background, before sketching in the ink outline shapes of the boats, and adding the coloured lights. *Anne Paton*

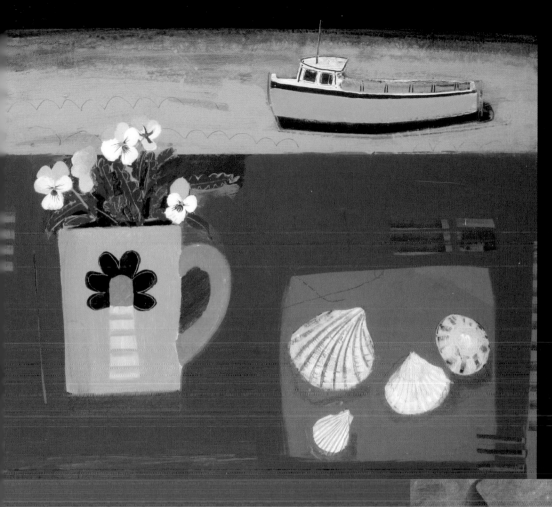

◀ Violas in my Favourite Mug

The deliberate flatness of this painting and the careful arrangement of line, shape, and colour force you to look at each individual element in turn, and then again at the whole. *Emma Dunbar*

▼ The Red Run Goblins

This is painted in a very illustrative manner, echoing its narrative suggestion. The quirky details make you look closer, to work out the story for yourself. *Emma Bray*

◀ Evening Light

Defying the rules, this picture experiments with using cool blues in the foreground, and warm reds and yellows in the background. The foreground is spattered with minute flecks of paint for texture and interest. *Paul Evans*

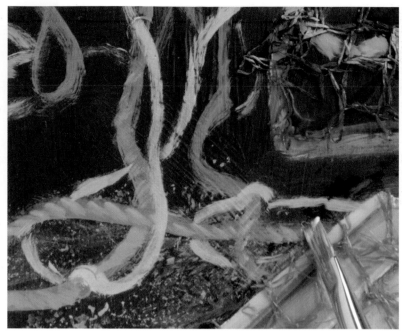

14 Allow the collage to dry overnight; the glue will become clear. Begin painting the string with a strong, bright colour – a mixture of phthalo turquoise and white – using the No. 4 brush. Colour the string as precisely as possible; accurate brushwork helps the rope stand out.

15 Using the No. 6 brush, apply a dilute mixture of Payne's grey and cobalt blue to provide darker tones over the shaded parts of the lobster cages. Add cobalt blue to this mix and paint the distant ropes in the top left of the composition; note how the ropes taper away into the background. With titanium white, Naples yellow, and a little cobalt blue, add oblique dashes over the blue ropes to indicate the twists of their fibres.

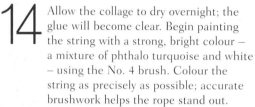

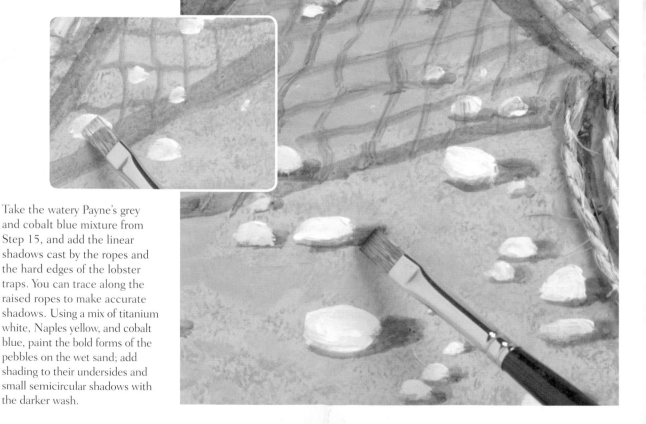

16 Take the watery Payne's grey and cobalt blue mixture from Step 15, and add the linear shadows cast by the ropes and the hard edges of the lobster traps. You can trace along the raised ropes to make accurate shadows. Using a mix of titanium white, Naples yellow, and cobalt blue, paint the bold forms of the pebbles on the wet sand; add shading to their undersides and small semicircular shadows with the darker wash.

17 Mix together titanium white, Naples yellow, and cobalt blue and paint lightly over the leading edge of the rope where it lies over the lobster cages. This indication of light striking the rope adds real depth.

18 Strengthen the painted rope to the right of the picture using a mixture of cobalt blue, phthalo turquoise, and Payne's grey. The combination of flat, painted rope behind the raised, glued string suggests layered coils of rope.

Lobster cage collage ▼

Vivid colour and collaged textures combine to make this composition jump into three-dimensional life. The choice of collage materials resonates with the subject, boosting the impact of the piece.

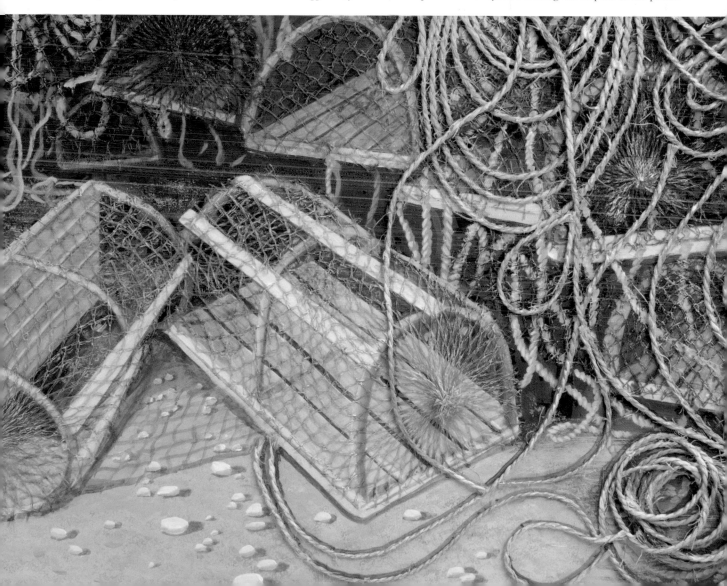

11 Forest path

This mixed media project combines the immediacy of pastels, the textural richness of collage, and the atmospheric qualities of ink with the versatility of acrylics. Each medium contributes specific qualities that add interest and depth to the painting. The result is a quick, effective landscape – a sure-fire way to build confidence. A mixed media piece is more than an opportunity to experiment with different painting elements – it is a great way to extend the imaginative range of your work.

EQUIPMENT
- Primed MDF board
- Brushes: decorator's brush, No. 14 flat
- PVA glue and assorted collage papers
- Acrylics: indanthrene blue, raw umber, Mars violet, Payne's grey, titanium white, Naples yellow, raw sienna, cobalt green light, cobalt blue
- Water-based inks: apple green and ultramarine
- Chalk pastels: salmon pink, yellow-green, cobalt blue, Naples yellow

TECHNIQUES
- Ink washing
- Collage
- Pastel overworking

1 Thoroughly wet the surface of the primed MDF board with the decorator's brush dipped in water. Pour the apple green water-based ink on to the surface in rough patches and then brush the ink over the damp surface with the brush.

2 Pour the ultramarine water-based ink to make patches of blue colour over the top of the green. Brush the blue ink over the whole board, but especially around the central area of the composition, where the shade of the forest is most intense.

3 Repeat the process with the apple green ink, brushing the pigment into the watery wash below. The result is a dappled ground, which captures the underlying tone and colour of the painting and can be overpainted with acrylic.

BUILDING THE IMAGE

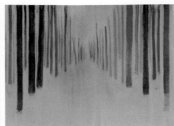

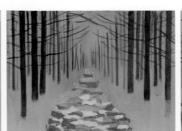

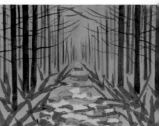

4 Tip the board on its side and allow the watery ink to run down its surface. The ink becomes lighter at the top, where light catches the tree canopy, and darker at the bottom, in the areas of dappled shade. The result is an intriguingly coloured and lightly textured background.

5 Map in the basic shapes and positions of the tree trunks using indanthrene blue acrylic applied with the No. 14 brush. Work while the background is wet, using both the broad and narrow edges of the brush for different widths of trees.

6 Mix raw umber and Mars violet with the indanthrene blue and darken selected tree trunks towards the front of the composition. This makes them appear more advanced in the picture. Darken the mix with Payne's grey and apply to the boldest trees in the foreground, still using the No.14 brush. The colour and strength of brushstrokes immediately creates perspective.

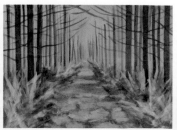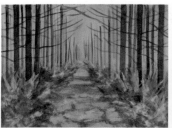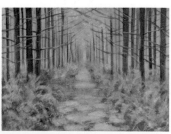

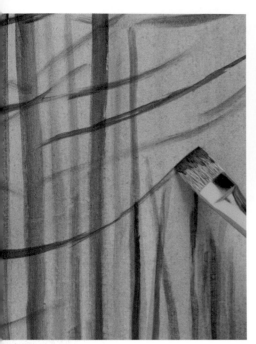

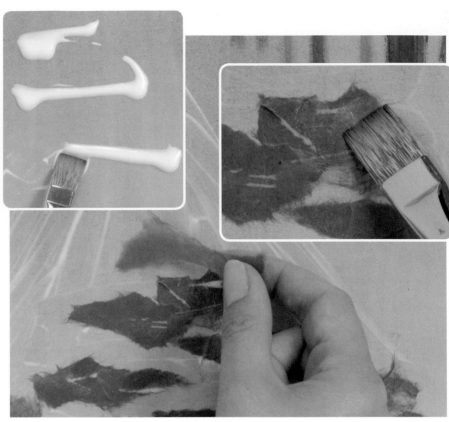

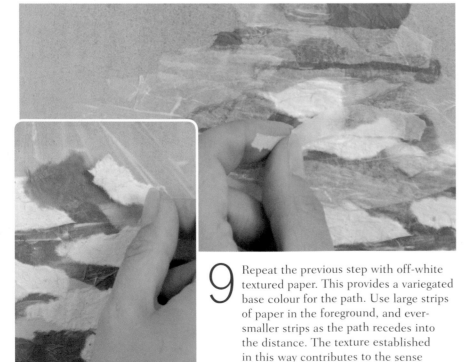

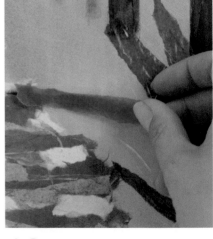

7 Add the branches of the trees using the edge of the No. 14 brush with the darker shade mixed in Step 6. Paint the branches so that they curve upward to meet in the middle, guiding the eye in towards the centre of the image. Vary the weight of brushstrokes to imply fainter branches in the distance.

8 Begin building the collage part of the image: squeeze PVA glue on to the path area and use the No. 14 brush to spread it evenly. Tear strips of burnt orange textured handmade paper and stick them down; then paint over the surface of the collage paper with the PVA glue.

9 Repeat the previous step with off-white textured paper. This provides a variegated base colour for the path. Use large strips of paper in the foreground, and ever-smaller strips as the path recedes into the distance. The texture established in this way contributes to the sense of perspective in the painting.

10 Tear dark blue tissue paper into strap shapes for the areas of foliage under the trees. Apply the paper as before, placing the torn strips on to a painted bed of PVA glue, then paint over them with glue to set them in place.

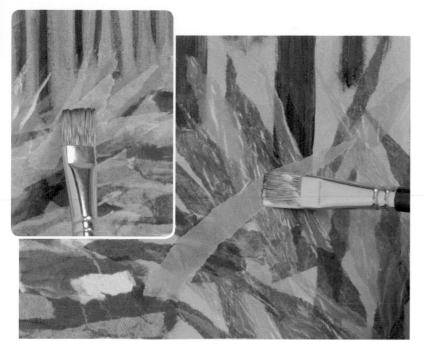

MIX AND MATCH

Acrylics can be freely combined with any water-based media, such as inks and watercolours, but not with oil-based paints – oil and water do not mix. However, once dry, acrylics may be overpainted with oils with no negative reaction.

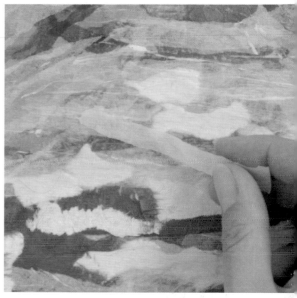

11 Continue building up layers of the collage in the foliage areas with strips of green and pale yellow tissue paper. Overlap the strips to create interesting forms and textures; paint over the collage with PVA glue as before to set the paper firmly in place.

12 Glue tiers of pale yellow tissue paper, torn in horizontal strips, on the path area to form "strata" that appear to recede into the distance. When the collage work is complete, set the painting aside overnight so that the glue is dry and ready to be overpainted.

"Textures can enhance or challenge natural forms."

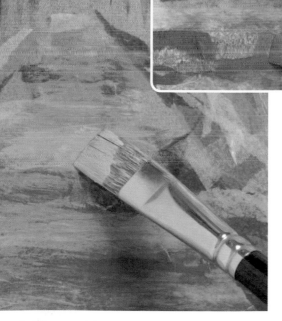

13 Start blocking in the darker areas of the path using a mixture of raw umber and Mars violet. Note how the underlying tones and shapes of the collage paper show through. Mix in a little titanium white and Naples yellow and apply loose patches of this colour to the path.

14 Paint some irregular dark forms over the foliage in the foreground using indanthrene blue, raw sienna, and a little Payne's grey applied with the No. 14 brush. This establishes the shadows within and beneath the forest plants.

15 Continue adding more patchy colour as a base for the vegetation; mix this from cobalt green light, cobalt blue, and indanthrene blue. Allow the rough working to spill over on to the shadier areas of the path.

16 Add titanium white and cobalt blue to the mix, and make irregular patches over the foliage. The layered colour gives a vivid impression of foliage, without the precise work needed to render each leaf.

17 Blend titanium white and Mars violet. Still using the No. 14 brush, make some brisk vertical strokes lightly over the top of the path, following its triangular form, catching the peaks of the collage paper.

18 Use the edge of the No. 14 brush to add warm light pink marks – made up from titanium white and Mars violet – on the upper faces of the overhanging branches. When dry, work over this paint with the salmon pink chalk pastel. Blend some areas with a fingertip, but leave others raw to boost texture.

19 Establish the structure of the ferns using the yellow-green pastel. Make a quick, helical squiggle from the top of the frond to the bottom. Smooth the pastel along the length of the frond with a fingertip; the collage beneath will suggest the structural complexity of the plants.

21 Work across the path area using the Naples yellow chalk pastel on its side. The pastel adds highlights to the areas of collage that stand proud, contributing to the fragmented texture of the leaf-strewn path.

20 Use the cobalt blue pastel to add leaf-like marks to the foliage along the path. Work more heavily in the distance than in the foreground, introducing more of the recessive blue colour. Smudge lightly with a fingertip to create a misty haze at the end of the path.

Forest path ▼

Mixed media provide a spontaneous feeling to this painting. Each medium sets up its own resonance, which is responded to by the next. This "conversation" between media gives the painting a freedom to find its own authentic voice.

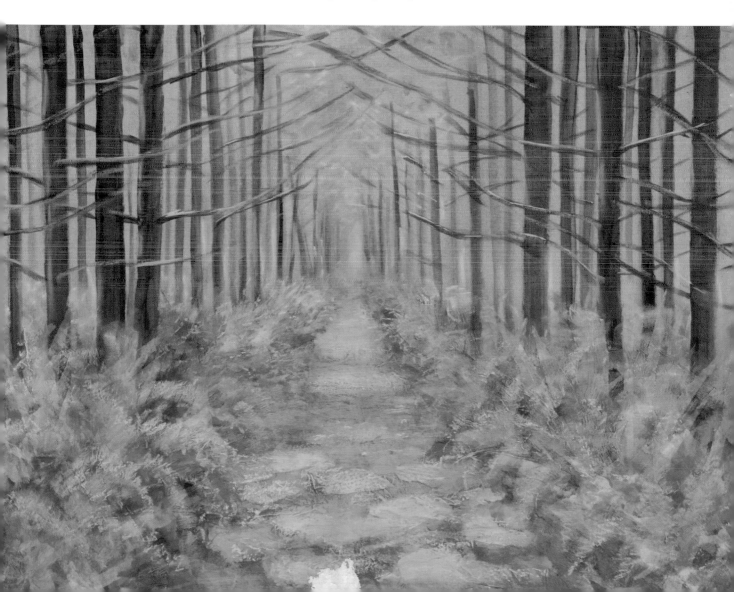

7 Add impressionistic reflections in the water, and in the wet sand, using pure titanium white spread on to the canvas with the No. 3 palette knife. Rub in the margins of the thick paint with a fingertip. Mix Naples yellow, indanthrene blue, and titanium white and brush the resulting mid-green tone patchily on to the wet sand to provide irregular texture.

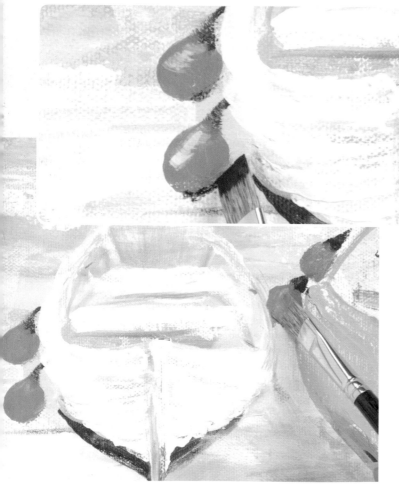

9 Using the mix of indanthrene blue, cobalt blue, and titanium white, pick out the ropes that tether the boats with the fine edge of the No. 12 brush. Their sinuous forms ensnare the viewer's eye, drawing it deeper into the picture.

8 Work on the fenders hanging from the boat. Mix a bright colour from quinacridone magenta, Naples yellow, and titanium white and use the No. 12 brush to paint their grape-like forms. Add more titanium white to paint their highlights; mix indanthrene blue with cobalt blue for shadows at their bases.

ABSTRACT CHOICES

An abstract landscape is made more in the head than on the canvas. Choosing a subject requires that you look at the natural world in a different way, attuning your eye to contrasts or repeating patterns of shape, colour, or texture, rather than representational detail. Be selective, and include only the elements that characterize that landscape for you at that particular moment in time. Refer to the natural scene as you paint, but extract from it only the information you need to paint.

10 Press the sharp blade of the 4 cm (2 in) wallpaper scraper into the dark paint mixed in Step 9. Pick up the paint, then press on to the canvas to mark the masts of the boats. Repeat this process using pure titanium white paint, for the masts that are lit by the sun.

Boats on the water ▼

The use of a wide wallpaper scraper as a painting tool has forced a novel approach on to a conventional scene. Large blocks of unrefined colour set out the planes of the landscape, with details, such as the ropes and sharp verticals of the masts, providing a recognisable sense of depth.

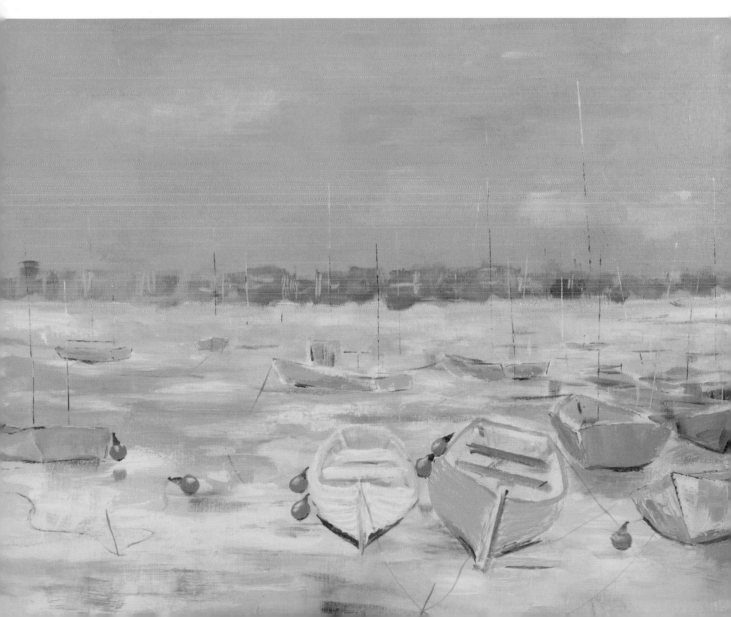

Glossary

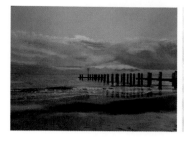

Acrylic paints
Fast-drying paints containing pigment suspended in a synthetic resin. These paints are water-soluble when wet and insoluble when dry.

Aerial perspective
The impression of distance achieved by manipulating the warmth of colours. Objects appear further in the distance when painted in a cool blue hue, and appear to advance further towards the foreground when painted in warm red or orange colours.

Analogous colours
Colours that are closely related and sit next to one another on the colour wheel – such as yellow and orange, or blue and violet.

Blending
Blurring the transition from one colour to another by stroking the two colours of paint with a brush or knife.

Brushwork
The brushmarks made and left visible on the canvas. These marks are often characteristic of a particular artist.

Canvas
Closely-woven cloth, usually made from linen or cotton, used as a surface for painting.

Colour field
A large area of flat colour. A colour-field painting is an abstract focusing on interaction between areas of pure colour, with less concern for form.

Colour wheel
An arrangement of hues around a circle, showing the relationships between colours.

Complementary colours
Colours directly opposite each other on the colour wheel that mix together to form a neutral colour. The pairs are: red/green, blue/orange, and yellow/violet.

Composition
The arrangement of various elements, including the main areas of focus and balance of interest, to create a harmonious painting.

Contrast
Differences between the tonal or colour values of areas within a painting.

Cool colours
Colours from the cooler half of the colour wheel: blue, green, and violet. These may be used to suggest distance.

Counterchange
Patterns of light and dark shades that are placed next to one another to create interesting contrasts.

Depth
The convincing illusion of three-dimensional space on a two-dimensional surface.

Dry brush
A technique where virtually dry paint is dragged across paper or canvas to produce textured marks, either directly on to an unpainted surface or on top of an existing paint layer.

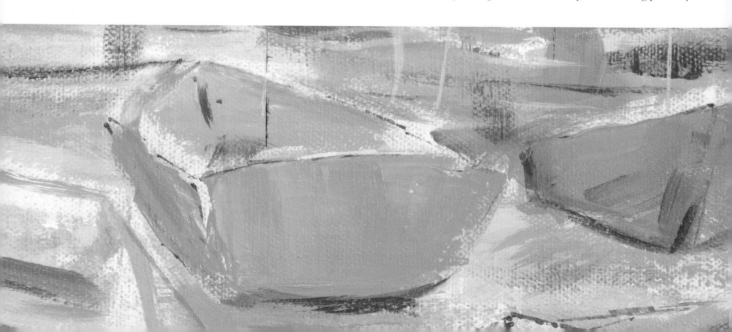

 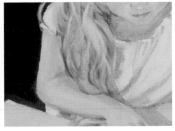

Figurative
A term used to describe art based on the human figure. Sometimes used to describe all non-abstract art that retains reference to the real world.

Flat colour
An area of a painting that has a single hue and intensity.

Focal point
A point of interest in a painting created by extreme contrast or intense colour.

Form
The solid shape of an object as seen from all possible angles and viewpoints.

Gesso
An acrylic-bound chalk and pigment mixture – usually white – used to prime surfaces before painting.

Glazing
The application of a transparent layer of paint over another layer of paint. The colours of the first layer show through the second layer of paint to create a shimmering new colour.

Ground
The actual surface on to which you paint, this may be white or coloured gesso, or a layer of colour on top of primer. A coloured ground may be used to help judge colour values.

Heavy-body paints
A thicker type of acrylic paint that retains brushmarks and is used for increased texture.

Highlight
The lightest tone in a painting, occurring on the most brightly lit part of a subject.

Horizon line
In linear perspective the imaginary line at eye level where converging lines meet at the vanishing point.

Hue
The term used to describe any pure colour; that is, one with a place on the colour spectrum or colour wheel.

Impasto
A technique where paint is applied thickly with a brush or painting knife to create a textured surface. The term is also used to refer to the results of this technique.

Landscape format
Describes the shape of a composition that is rectangular, and wider than it is high. This format was traditionally used for painting large-scale landscapes.

Layering
Painting one colour over another colour that has been allowed to dry. Unlike glazing, the colours used can be dark and opaque, so that the under-layer of paint does not show through the top layer.

Linear perspective
A particular kind of drawn perspective, where parallel lines formed by objects appear to converge at a point on the horizon called the vanishing point.

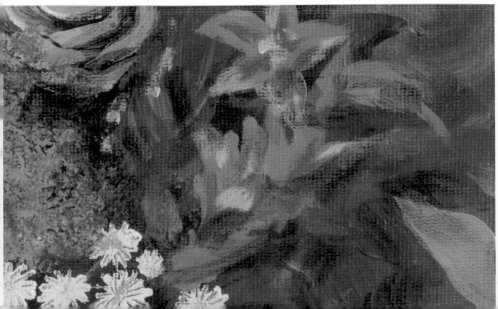 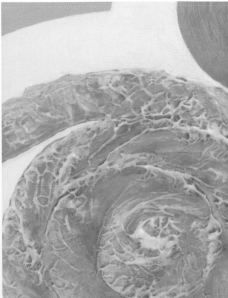

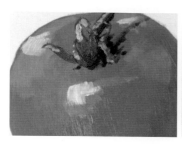

Medium
Three alternative meanings:
1 The type of art materials in which an artist is working; such as oils, watercolours, acrylics, or pastels.
2 A liquid in which colour pigments are suspended, which acts as the carrier element within a paint.
3 A paint additive which alters one or more properties of the paint, such as a flow improver or retarder.

Mixed media
The use of a range of media – such as a different types of paint, fabric, or even objects – within one painting.

Neutrals
Colours produced by mixing two complementary colours in equal proportions.

One-point perspective
A composition where the elements are arranged on the canvas with a single vanishing point on the horizon.

Opaque
Colour that is impervious to light, which obscures anything underneath; the opposite of transparent.

Paint support
The paper, canvas, fabric or board that forms the surface for painting.

Palette
A mixing area for paint, or a range of selected colours used for a particular painting.

Perspective
The method of creating an illusion of depth and distance on a flat surface (*see also* Aerial perspective *and* Linear perspective).

Pigments
Finely powdered particles with inherent colour which are added to a binder – such as acrylic resin – to form paints of various colours.

Portrait format
A rectangle that is taller than it is wide. This format was traditionally used as a shape for standing portraits.

Primary colours
The three colours that cannot be created by mixing together other colours. The primaries are red, yellow, and blue. Any two of these colours can be mixed together to make a secondary colour.

Primer
A coating material applied to a support in order to prepare it for painting.

Proportion
The relative measurements of one object, such as the height compared with the width, or the relative measurement of one area to another.

Recession
Perceived movement from near to far distance within a painting. Colour recession is the use of warm and cool colours to create the sense of depth within a painting.

Resist
A method of preserving highlights on white paper or a particular colour by applying a material that repels paint.

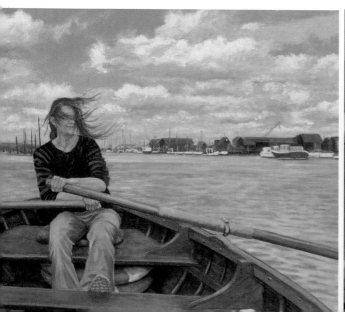

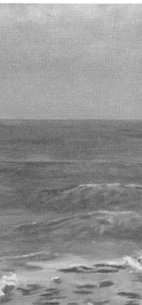

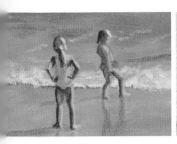
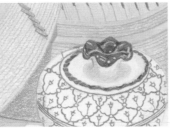

Rule of thirds

This rule states that if you divide a picture into thirds vertically and horizontally, then place points of interest at the intersections of these lines, your composition will have increased interest and balance.

Scale

Objects that are the same size appear to get smaller with distance. Two same-sized buildings, one close and one distant, drawn to scale, would be drawn at different sizes.

Scratching

Scraping off paint with a painting knife to reveal the colour below (sgraffito).

Scumbling

Dabbing a dry brush or sponge lightly loaded with paint over a dry, painted area so that patches of the colour underneath show through.

Secondary colours

Colours that are made by mixing together two primary colours. There are three secondary colours: orange, created by mixing yellow with red; violet, made when red and blue are mixed together; and green, which is made by mixing blue with yellow.

Spattering

Flicking paint from a loaded paintbrush or toothbrush to produce fine spots and splatters of paint.

Sponging

A technique whereby a sponge is dipped into wet paint and then dabbed on to the painting to create a mottled effect for increased texture.

Stay-wet palette

A manufactured paint palette designed specifically for use with acrylic paints. It has a damp layer under the main mixing surface to keep paints moist while being used.

Texture paste

A painting medium that is added to the acrylic paint to build up heavy impasto – or raised – textures.

Tint

A colour obtained by adding white to a paint colour.

Tone

The relative lightness or darkness of a colour. The tone of a colour can be altered by diluting it with water or mixing it with white paint or with a darker pigment.

Translucency

Clear, transparent effect, achieved by adding water or medium to the paint.

Value

Lightness or darkness of a colour. Black and white lie at either end of the value scale.

Vanishing point

The point at which parallel lines appear to converge at the horizon line.

Warm colours

Colours with a reddish or orange tone. Warm colours appear to advance in a painting and can be used to help create a sense of depth.

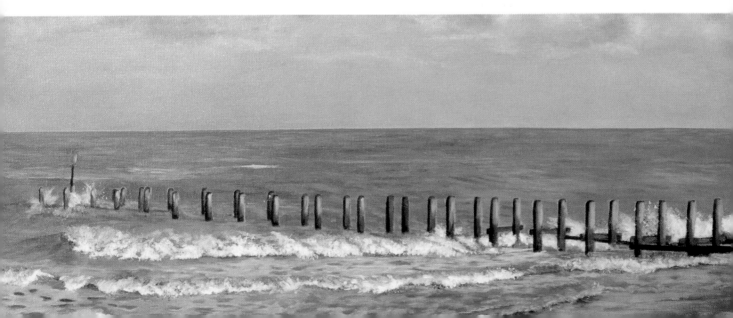

Index

Acknowledgements

AUTHOR'S ACKNOWLEDGEMENTS

My thanks and love to my family Kevin, Charlie, and Olivia for being so supportive and understanding throughout the making of this book. Also thanks to Graham Simper of Thompson's Gallery, Aldeburgh for supplying artwork to be included in the gallery pages. Finally I would like to acknowledge Rebecca Johns and Marek Walisiewicz for their guidance, patience, and friendly and fun company during the project work.

Visit the author's website at:
www.ksjkeable.co.uk

PICTURE CREDITS
Key: t=top, b=bottom, l=left, r=right, c=centre.

p.10: Neil Smith; *p.12:* Sylvia Paul (b); *p.14:* Jacquie Turner (b); *p.15:* Neil Smith (b); *p.17:* Terence Clarke (b); *p.25:* Dianne Urwin (b); *p.27:* Dianne Urwin (b); *p.28:* Jacquie Turner (tl), Dianne Urwin (bl); *p.29:* Barry Atherton (tl), Terence Clarke (b); *p.55:* Paul Apps (b); *p.56:* Paul Hedley (t); *p.57:* Ikahl Beckford (b), © Private Collection/The Bridgeman Art Library; *p.58:* Paul Apps (tl), Dianne E. Flynn (b); *p.59:* Paul Hedley (t), John Worthington (bl), Anne Paton (br); *p.74:* Paul Evans; *p.78:* Brian Yale (tl), © Private Collection/The Bridgeman Art Library; Ben Schonzeit (bl), © Private Collection/Ltd Editions for Ben Schonzeit/The Bridgeman Art Library; *p.79:* Paul Apps (t); *p.80:* Anne Paton (b); *p.81:* Terence Clarke (tr), Paul Evans (bl), Colin Slee (br); *p.100:* Dianne Urwin (t), Terence Clarke (b); *p.101:* Emma Dunbar (t), Paul Evans (b); *p.102:* Sylvia Paul (t), Barry Atherton (b); *p.103:* Jacquie Turner; *p.104:* Jacquie Turner (t), Sylvia Paul (br), Anne Paton (bl); *p.105:* Emma Dunbar (t), Emma Bray (br), Paul Evans (bl).

All jacket images © Dorling Kindersley.